Colour Confident Stitching

How to create
beautiful colour palettes

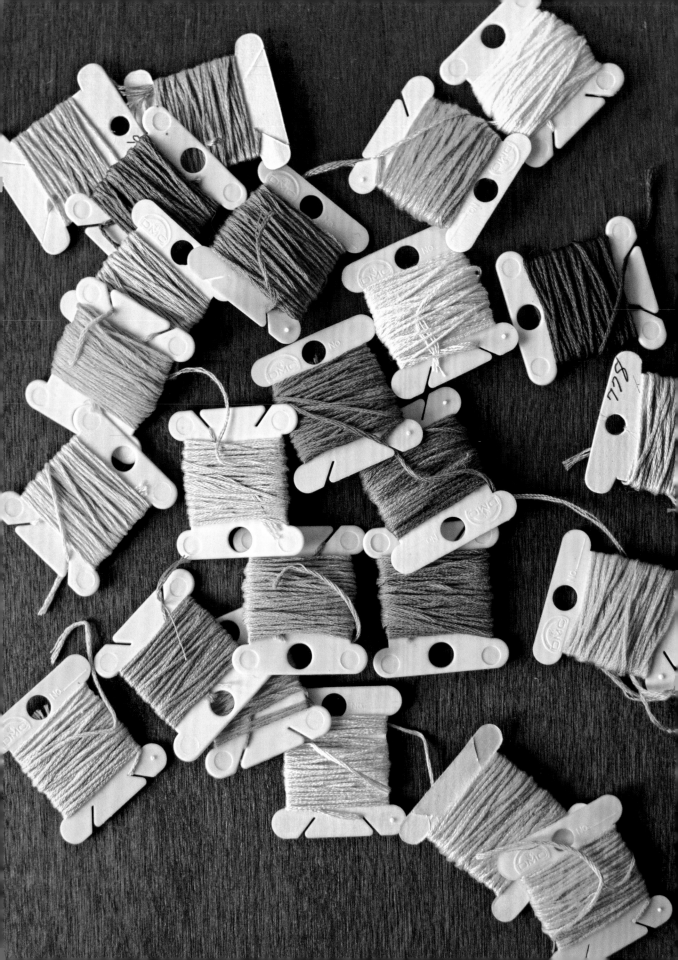

Colour Confident Stitching

How to create
beautiful colour palettes

Karen Barbé

PIMPERNEL
PRESS LTD
www.pimpernelpress.com

Dedicated to my niece Violeta Venegas Barbé.

Pimpernel Press Ltd
www.pimpernelpress.com

Colour Confident Stitching
Copyright © Pimpernel Press Ltd 2017
Text copyright © Karen Barbé 2017
Photographs © Karen Barbé 2017
Design by Becky Clarke Design

First edition published 2017

A catalogue record for this book is
available from the British Library

Typeset in Rockwell

ISBN 978-1-9102-5865-1
Printed and bound in China

9 8 7 6 5 4 3 2 1

ABOUT KAREN BARBÉ

Karen Barbé is a textile designer, embroiderer and blogger. Her work
combines her love for traditional crafts, folklore and textiles, with a solid
design background that influences a thoughtful process of research,
conceptualization and production of a body of work that spans home textiles,
accessories and fashion. The result of this unique mix is a world that evokes
qualities of warmth, simplicity and comfort.
www.karenbarbe.com

ACKNOWLEDGMENTS

Thank you to my dear family,
for their constant support and help;
all my students, who never cease to
inspire and teach me new things;
Paz Cox, for her colour knowledge
and guidance; Anita Schacht and
Paulo Román, for their work and
fresh ideas; Raúl Prado, for his
ever-present helping hand; Caro
Rojas, for her embroidery talent;
Rodrigo Zuloaga, for his advice and
continuous encouragement; and, of
course, my editor Anna Sanderson,
for being that guiding light in
this process.

CREDITS

PHOTOGRAPHY AND STYLING:
Karen Barbé
STITCHING:
Karen Barbé, Greta Abrigo,
Carolina Rojas
STITCH ILLUSTRATIONS:
Ana María Schacht, Paulo Román

COVER PHOTOGRAPH
All samples were stitched by
students during one of the author's
embroidery workshops.

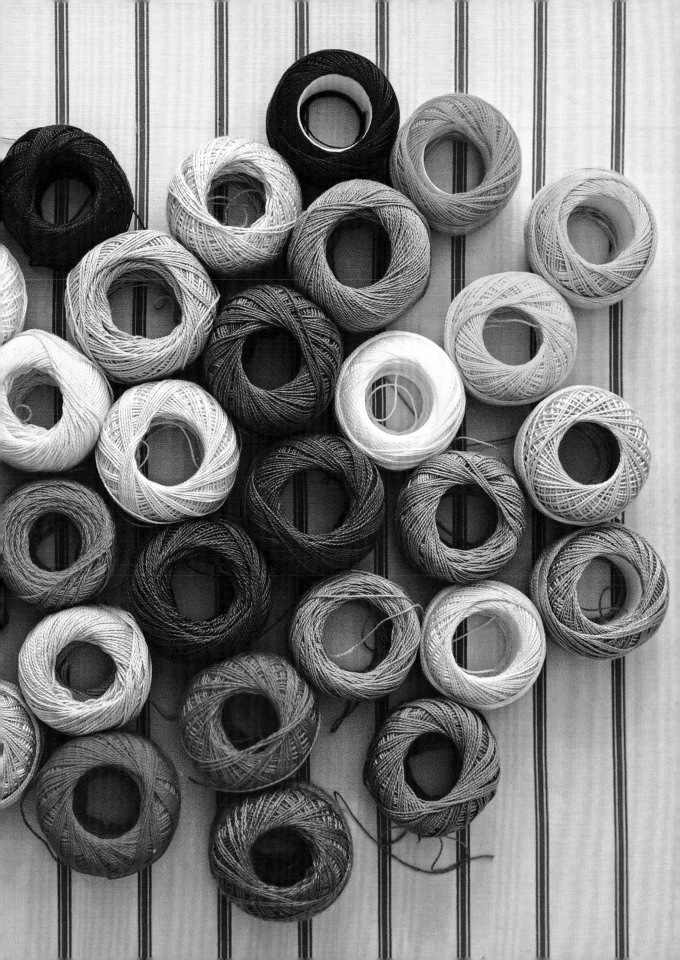

Contents

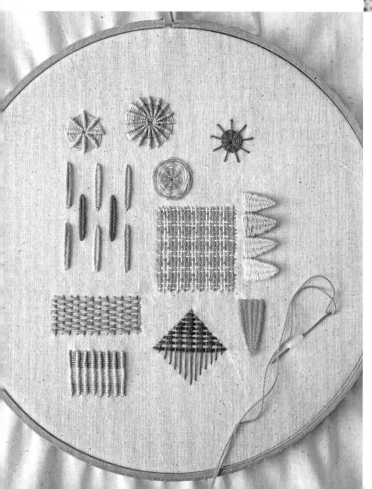

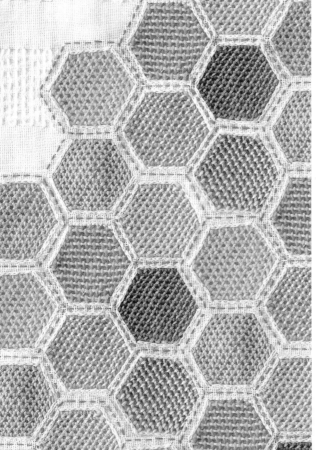

Introduction

Some people seem to be born with a talent for colour and are able to choose and arrange beautiful colour combinations effortlessly. These people have an 'eye for colour'. Perhaps they have taken art classes or have just been more sensitive to colour from childhood. These people, by observing their surroundings, have developed an ability for working with colours, whether it is choosing their clothes, decorating their homes or stitching a personal project.

The good news is that colour is a skill that can be learned. It does not matter how many times you feel you have failed in the past when choosing colours. We all have the potential to shine just by learning the process and putting it into practice. Although the focus here is embroidery the theory and process of creating colour palettes has many potential applications beyond stitching.

Parts 1 and 2 guide you through two different dimensions of the world of colour and explain their distinct ways for creating colour palettes. The first relies on **colour theory** concepts (like colour schemes, hue, value and saturation, colour moods). The second part delves into **colour sensitivity** as a means of training your eye for spotting colours in your everyday life—in nature, your surroundings or your favourite objects—and learning how to extract and integrate them in a fresh and original palette.

The best way to learn is to experiment and play. The five projects in Part 3 are an opportunity to put learning into practice.

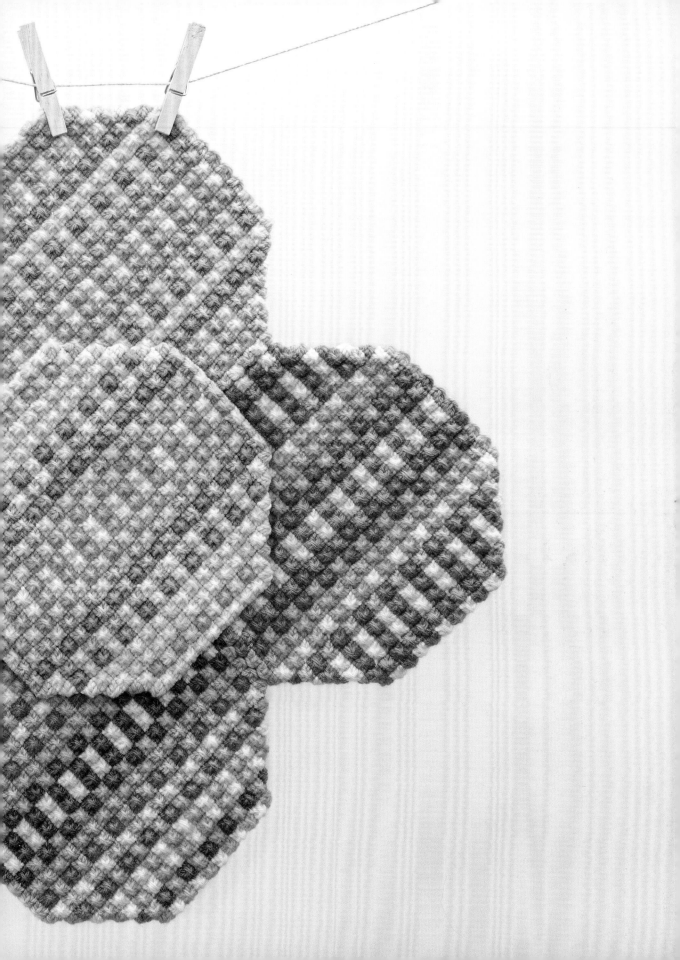

Understanding Colour Palettes

Colour is so much more than beautiful, harmonic, striking or trendy combinations that we see in clothes, design magazines, shops, museums, in people and in nature. Colour is about emotions and senses; it is about an inner feeling conveyed by a mix of these in such a way that they transmit a clear message, create a mood or foster a positive or negative reaction. Colour is communication. From the pastel colours of a baby's room to the darker and rich shades of a theatre, all colours build an atmosphere and express a specific concept.

This is the core of working with colours: **we need to know what we want to communicate before choosing any colours**. And this is the hardest part. Creating a successful colour palette is not only about choosing colours that work nicely together but being able to 'read' the context or object and decide what it is that you want to convey. This is key to making your palette shine in a proposed project.

What is a palette?

A palette is a fun and fascinating colour tool to use with creative projects. It is a colour guide that presents a harmonic and beautifully arranged colour combination that can be applied to a given project in order to enhance its visual quality and emphasize symbolic values or emotional attributes. It is usually represented as a rectangular piece divided into several adjoining colour slots.

What is a colour chart?

A colour chart is a collection of colours selected for a particular project and arranged in a specific sequence to help visualize them. Colours in a chart do not sit next to each other like in a palette (there is a space between them) and they each have their name or code for reference. A project can consider roughly twelve colours (less or more); different palettes can be created from a project colour chart and a palette does not have to include all the displayed colours. Commercial colour charts can range from dozens to hundreds of colours available for a material or medium.

How many colours?

A palette can be built from one to four distinct hues each presented in varying intensities (tints, shades and tones, see pages 22–3). Usually five to six colour variations are displayed in a palette but there can be up to twelve depending on the project. Every slot is filled with one of the colours and its width represents the proportion of colour to be applied on the final project, see pages 46–7.

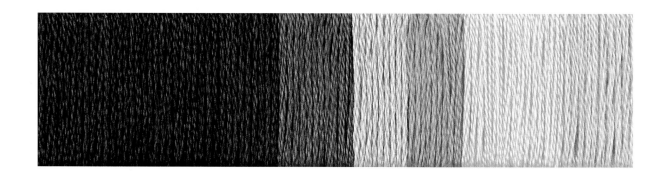

How are colours arranged?

Colour slots are arranged along the palette to create a sequence or rhythm that enhances the relationship of the presented colours. They can be distributed according to their changes in lightness/darkness, saturation and/or to their location on the colour wheel or in the original source. The goal is to obtain a sequence that shifts seamlessly between colours slots. The placement of colour slots can also indicate which colours work or look best next to each other when applied in the final project.

How do I make a colour palette?

This book will guide you through different methods for creating your own beautiful colour palettes. You can use colour pencils, colour papers, paint chips and embroidery floss or yarn wrapped around a card stock rectangle. You can always go digital and try colouring palettes in your preferred productivity software using cells or rectangles with different colours.

How do I use a colour palette?

A colour palette is a project in itself that ideally should be created at the same time as designing or creating your motifs. The palette will work as an inspiring reference when applying and arranging the colours in your project so you are able to transfer the appeal and mood from the original source into your creation. Once you grasp how to create colour palettes you can make lots and collect them in your colour folder/journal for future reference or use.

Building a palette through colour theory

In Part 1 you will find an in-depth explanation of the concepts of colour theory underlying each of the following steps. You will learn what colour means and how every decision around colours affects the essential nature of your creative project.

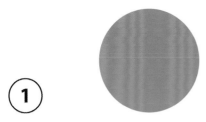

Choose your colour
Whether it is a colour you like, dislike (usually they come as part of a commission), must use (for it blends with an existing space or object) or because its associated meaning reinforces your intended message, every colour palette has a starting colour(s) that sparks off the rest of the process.

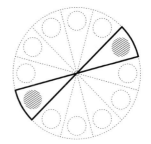

Choose a colour scheme
You will learn that colours can be related to each other through colour schemes, such as monochromatic, complementary or split complementary schemes. Each of these proposes a particular dialogue between hues. Some of them are explosive and complex while others can be balanced and calming. The colour scheme will determine the inner personality of your palette.

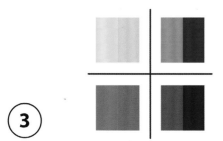

Choose the colour mood
The impact and response of your colour palette relies not only on the hues selected in Step 1 but in the atmosphere that can be created by varying the lightness, darkness and/or intensity of them. We will refer to them as light, dark, vivid and muted moods and they create the initial impact of your palette.

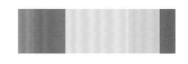

Choose the colour roles
This is about the proportions and importance that specific colours will play in the palette. There are three distinct colour roles within a palette: dominant, subordinate and accent. Just as when a casting for a film, the roles are assigned according to their relevance to the 'plot' so we can emphasize or just give a hint of a given message we would like to communicate.

Building a palette through colour sensitivity

If creating a palette through colour theory is about understanding the relations between colours, working from colour sensitivity means using an instinctive approach when choosing and arranging your colours. This path, explained in Part 2, is more advanced as it relies on a well-trained eye that is able to spot exquisite colour mixtures and apply them successfully in a different place or project.

1

Find a chromatic source
Search your surroundings until your eye detects a rich chromatic source—it can be anywhere, a corner of a room, a picture in a magazine or even imagined from a sentence you read in a book—a source that ignites an unexpected and marvellous colour combination.

2

Capture the colours
Once you have your inspiring source, you will have to pull out the essential and most meaningful shades that form it. This step can be done manually or you can use digital tools.

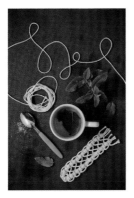

DMC 312	DMC 336	DMC 823

3

Build a colour chart
Once you have all the captured shades, you need to choose which ones to keep in order to build a limited, but expressive colour chart for your project. Then translate each selected colour to the closest match found on the commercial colour chart of your preferred material or medium.

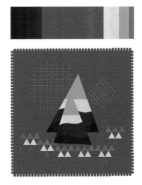

4

Create your palette
Design different colour combinations in order to create several palettes out of one colour chart. Use a colour plan sheet (see page 72) to help you visualize all the alternatives and decide which is the most appropriate for your embroidery piece.

Understanding Colour

The words 'colour theory' may sound daunting because we immediately visualize a kind of abstract thinking that appears to have little in common with the way we use colours in the real world. That is why we have organized that same abstract knowledge in an accessible manner that will guide you through a 4-step process of creating colour palettes so that you will know how, when and why to choose a given colour combination.

This first chapter is a starting point for training your eye in colour matters. Even if you feel confident about your colour skills, you can always benefit from reviewing it as you may realize that some of the palettes you make intuitively can be explained by colour theory.

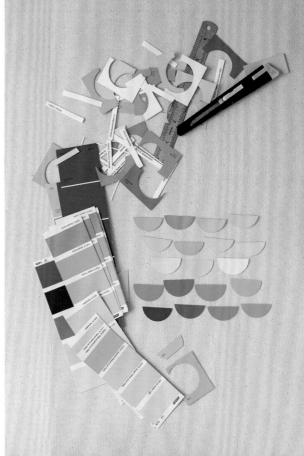

The Colour Wheel

When we work with colours we need to start seeing the world in a new way: suddenly it is no longer a red cherry that we have in our hands but a marvellous source of reds that range from the brightest pink-red to an intense and dramatic burgundy shade. It is about viewing the world not as the things we see but as the colours they actually are (or the light they reflect, to be more precise). Our eye will gradually learn to distinguish the different hues and recognize that materials or surfaces render colours in their own particular way: have you ever seen a vibrant picture on your computer only to discover that when it is printed it loses a lot of that intensity? That is because light and inks have different colour spectrum widths.

RGB and CMYK colour model
Light is based on the RGB model which works with Red, Green and Blue light, which added together can create a wide array of colours. This colour model can be found on screens, TVs, image scanners, mobile phones and computer displays.

The CMYK model refers to colour inks, paints and filters. If you have ever looked at the colours of your inkjet printer cartridges you may have noticed that all printable colours can be achieved by Cyan, Magenta, Yellow and Black inks.

RYB colour model
The colour model we will be using is the RYB which is mostly used for art education. It comprises the three primary colours (Red, Yellow and Blue—hence the name) and the colours resulting out of mixing them (secondary and tertiary colours). The mix of two primary colours yields a secondary colour (orange, green, violet). The mix of a primary with a secondary colour results in a tertiary colour. These three groups render a total of twelve colours: three primary (red, yellow and blue), three secondary (orange, green and violet) and six tertiary (yellow-orange, yellow-green, blue-green, blue-violet, red-violet and red-orange). All these hues appear in the RYB colour wheel in the order in which they were created.

Using the colour wheel
The usual representation of the colour wheel resembles a twelve-slice pie where each portion belongs to one of the colours. However, rather than think of the colour wheel as an actual roulette with solid colour sections, see it instead as an abstract representation of all the colours contained in each slice. So although we would classify a cherry as 'red', a closer inspection would reveal a handful of other reds. Therefore when you use the colour wheel keep in mind that you are not working with a definite colour but the broad range of shades that can be recognized as that colour.

On the colour wheel each hue blends into its neighbour creating a smooth transition from one side to the other of the wheel. For instance, the colour yellow takes three blending steps toward blue: yellow-green, green and blue-green. The transition of yellow to blue happens easily because the steps in between are the result of their mix on two levels: first their mix as a secondary colour (green, in this case) and then between each primary and the secondary (resulting in the two tertiaries— yellow-green and blue-green).

The colour wheel is a useful tool when working with colours and understanding the existing

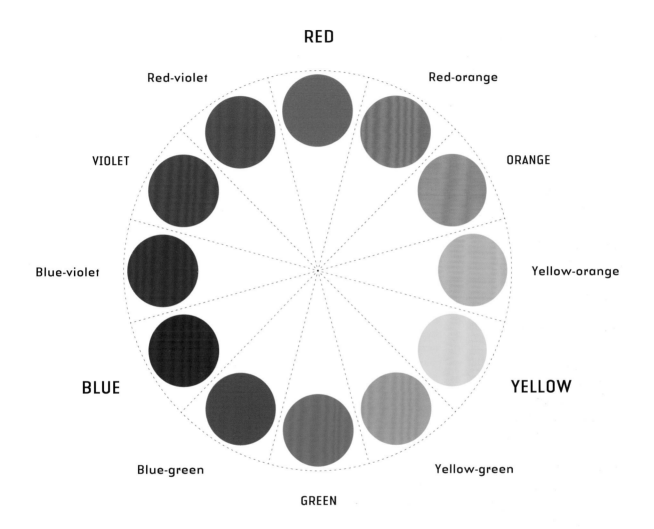

RED

Red-violet Red-orange

VIOLET ORANGE

Blue-violet Yellow-orange

BLUE YELLOW

Blue-green Yellow-green

GREEN

DIFFERENT COLOUR MODELS

CMYK is used for all printable colours.
RGB is used on digital screens and
monitors.
RYB form the basis for mixing and
creating a total of 12 colours (see above).

CMYK

RGB

RYB

and possible relations between them. While you don't need to learn by heart whose parents are who, it is helpful to roughly memorize the position of each hue in the colour wheel as their place is not interchangeable. Red will always be next to red-violet and red-orange just as yellow-green will always be flanked by yellow and green.

Mixing colours

Notice that primary, secondary and tertiary denominations not only offer an indication of what level of formation colours belong to but they also hint at the colour formula implied in its mix. Thus primary (1) indicates an original colour; secondary (2) marks the adding of two primaries and tertiary (3), the mix of one primary and one secondary, which can also be seen as one primary plus two parts of another primary. For example, the tertiary blue-green is the result of blue (1) + blue (1) + yellow (1).

RED (1)
RED-ORANGE (3) = RED (1) + ORANGE (2)
ORANGE (2) = RED (1) + YELLOW (1)
YELLOW-ORANGE (3) = YELLOW (1) + ORANGE (2)
YELLOW (1)
YELLOW-GREEN (3) =YELLOW (1) + GREEN (2)
GREEN (2) = YELLOW (1) + BLUE (1)
BLUE-GREEN (3) = BLUE (1) + GREEN (2)
BLUE (1)
BLUE-VIOLET (3) = BLUE (1) + VIOLET (2)
VIOLET (2) = BLUE (1) + RED (1)
RED-VIOLET (3) = RED (1) + VIOLET (2)

1 = Primary colour
2 = Secondary colour
3 = Tertiary colour

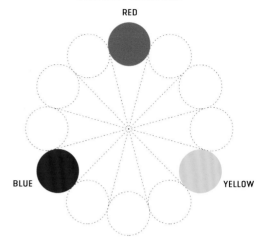

PRIMARY COLOURS

RED

BLUE

YELLOW

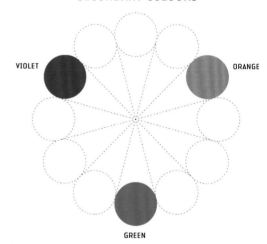

SECONDARY COLOURS

VIOLET

ORANGE

GREEN

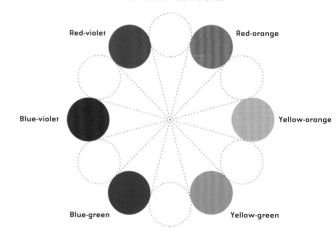

TERTIARY COLOURS

Red-violet

Red-orange

Blue-violet

Yellow-orange

Blue-green

Yellow-green

Colour Meaning

Colours are pure emotion, pure meaning. When we choose a certain hue we might have the intuition (or the knowledge) of what it conveys or be completely clueless about its meaning. However, you want your colour decisions to be accurate so they boost the piece they are colouring. Remember that the message conveyed by a given colour not only relies on its meaning as a pure hue but also in its value and saturation.

Choosing a colour can be difficult but keep in mind that there are no right or wrong choices nor rules to follow. Observe how colour is used in different objects or contexts and decide if it works with your idea.

Baby blue and pink have traditionally been used for boys' and girls' clothing and home decor but in recent years fashion has introduced garments for men in pink or lavender, a trend that definitely clashes with tradition. You will find that there are some projects that have more closed boundaries when it comes to colour usage but if you are going for personal stitchery, why not dare to try something new?

Overleaf there is a brief profile of the main characteristics of each colour family. Tertiary colours are not included as they share traits from both their original source colours (the primary and secondary that stand on each side).

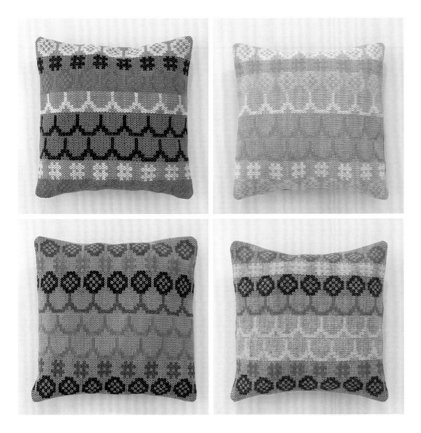

The different colour choices infuse each cushion with a specific character. The pink and yellow one has a soft, girly mood to it while the cushion in beige and orange conveys a warm and natural feeling—both have very distinctive personalities and it's not hard to imagine the kind of place or room they would sit in. The other two cushions share a more contemporary and bold look as they blend very bright colours with neutral shades—the use of yellow and orange adds to that bold and cheerful character.

YELLOW

Lively, bright, fun, yellow is cheerful like rays of sunshine. Yellow is the colour of the sun, blonde hair and gold. It is the lightest hue and therefore is easily blended with other colours. It feels sour to taste and can be related to envy, jealousy and lies. Pale yellow conveys sweetness, bliss and softness, and it is always friendly and welcoming in its manner. A warmer yellow speaks of autumn and harvest. Gold, as the metallic version of yellow, represents luxuriousness, warmth and royalty.

VIOLET

The traditional colour of royalty, power, theology and magic, violet is worn by emperors, kings, and rulers. It symbolizes the clash and merger of two radically different hues— red and blue—therefore it summons contradictory feelings among people. Violet shades appear luxurious, elegant, alluring but also mystic and spiritual. In its paler versions like lilac and lavender, it looks gentle, delicate and floral.

BLUE

This is the colour most often cited as a favourite; blue expresses tranquility, spirituality and harmony. It is the colour of the sky and the sea. In its paler versions blue appears clean, silent, peaceful and soothing yet in its vibrant state (like a electric blue) it transmits that stamina and vitality to anything it colours. The more traditional navy blue comes out as reliable, solid and serene.

WHITE

This is the colour of light. Things in white come out as good, innocent, clean and pure: from angels and good spirits, heaven and white brides to clinical spaces. All colours blended with white result in softer, lighter and gentler versions than their original.

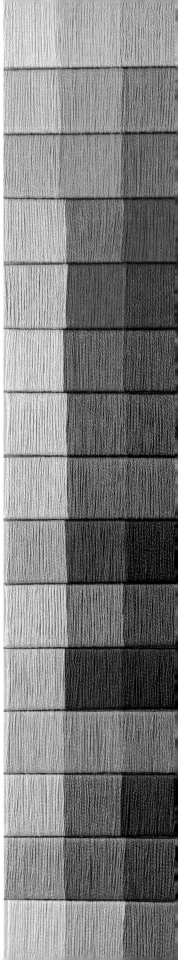

ANGE

..., sociable and cheerful like yellow but orange ...lso striking and hot like red. Orange is exotic, ...y, juicy, the colour of richly prepared foods, ... best colour to whet your appetite whatever the ...sen shade. If used in signals or graphics, it will ...nitely catch your eye and boost creativity. The ...e apricot version is soft, sweet and cosy while in ...darker terracotta form, it recalls rustic materials ...e clay and speaks of earth, soil, sunset and ...rmth.

RED

This is the colour of passion from ardent love to fiery aggression and hate. Red is the colour of blood and fire. It is a warm hue and as such will always look closer and manage to catch the eye first (red in traffic lights and other street signals). In its soft version, pink conveys sweetness; it is soft and romantic while in its deeper burgundy form, it is all about elegance and richness. And fuchsia is hot, fun and sexy.

EEN

...s is the colour of nature—grass, foliage, stems and leaves, growth and fertility. Green is the colour ...ife and hope but also poison. It is all about spring, new shoots, freshness, ecology, outdoor life ...l youth. Green is the most calming of colours, especially in its lighter versions that help create a ...axed and neutral mood. The darker shades of green are linked with forests, tradition and money ...le in its olive version, it pairs with military, safari and outdoor adventures.

UTRALS

...trals dwell in an ambiguous colour space— ...y appear almost as grey (or white) but still ...tain a dab of colour that can make them ...netimes confusing to recognize. Colours like ...ge, taupe, sand and ecru are neutrals that are ...stly connected to their source in nature like ...bbles and stones, soil, tree bark, etc. They ...ng a classical, quiet and tempered feeling when ...lied.

BLACK

The absence of colour, black is the strongest shade—no one can be darker or appear more powerful than it. Death, mystery, shadow but also power, elegance, tradition can be conveyed by this enigmatic colour. If used in its lighter forms, grey looks professional, sleek, classical and restrained.

Value and Saturation

What about all the other colours that are out there? We have seen more than twelve colours in the world around us. What about pink, brown or grey? And white and black? The colour wheel is an abstract representation of how colours are distributed in the visible spectrum and it serves as the starting point for understanding colours. Now you need to imagine the colour wheel in a three-dimensional structure to be able to visualize all the other colours.

Imagine the visible colour space as a building where the twelve colours live together, along with their light, dark and muted versions. The colour wheel would sit on the ground floor and the rest of the building would project in a conical shape up toward the sky as well as down underground.

All the colours above the ground floor are lighter as they have more white in their composition, while those that dwell in the underground section of the building are darker as they are mixed with black. This is what we will refer to as **value**: the lightness or darkness of a given colour according to the amount of white or black in its formula. The value shifts in the

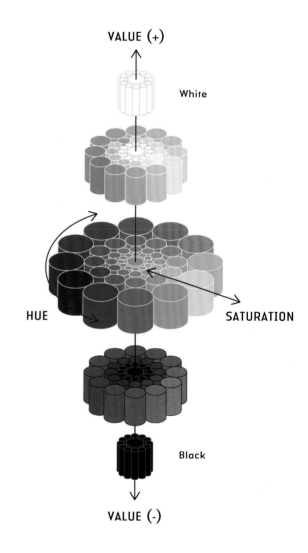

VALUE (+)

White

HUE

SATURATION

Black

VALUE (-)

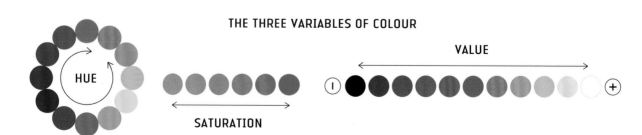

THE THREE VARIABLES OF COLOUR

HUE

SATURATION

VALUE

(I) (+)

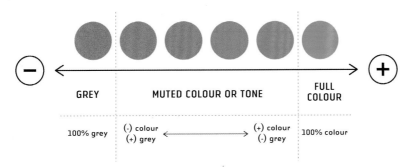

vertical axis, just like a lift goes up and down in a building. The upper and lower points of this conical building are represented by pure white and pure black respectively. So when we think, for example, of blue, we will know that baby blue and dark navy are still considered to be versions of blue with different values. The same applies to pink and burgundy—they are all versions of red living on different floors.

Saturation, sometimes also known as chroma, refers to the intensity or purity of a given colour. That means how much grey is in its composition. Adding grey makes a colour duller as it tarnishes the vibrancy of the pure colour. If we think of our colour building, vivid colours (the most saturated) are those that live closer to the windows of the building. Moving toward the centre of the building, colours shift gradually to grey: vivid colours become muted and finally convert into pure grey. The lightness or darkness of this pure grey will depend on the value of the involved colours.

As this is a conical building, colours near the top or the bottom are also closer to the centre

of the structure meaning that they also have less colour information in their formula as they approach the white or black apex.

Up to this point we have labelled the possible modifications of colours as intensities or versions of colours. Now that we know about the complexity of the spectrum in its formation and distribution, we are able to use the proper terminology to refer to the various states of colours: hues, tints, shades and tones.

Hue refers to the name of the colour as it appears in its purest state. Think of it as fresh colour, 100% pure colour without any white, black or grey in it.

Tint is the mix of a pure colour with white. The amount of white can vary so the mix can range from a light colour to a white with a hint of colour. All light and pastel colours are tints.

Tone is the mix of pure colour with grey. Muted and dull colours are tones of a pure colour.

Shade is the mix of pure colour with black. Dark colours are referred to as shades. The word shade sometimes is used as a synonym of colour (in a broad sense).

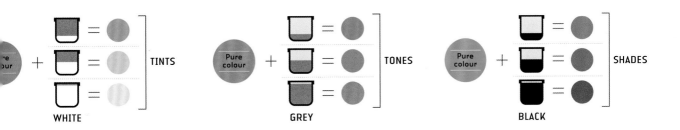

Temperature

As you go round the wheel colours tend to get cooler or warmer than their neighbour depending on the direction you are going. When we say cool we are referring to those colours that convey a sensation of coldness, reminding us of fresh water, ice, snow, air, shadow and humidity; warm colours, on the other side, deliver a sunny feeling of heat that recalls sunlight, fire and dryness. Warmer colours express energy and excitement and always manage to grab our attention with their cheerful, bright and aggressive mood while cooler hues stand for the opposite—they are calming, thoughtful and tranquil. Warmer colours are always perceived as closer to the eye (and therefore will be noticed first) than cooler hues so keep this phenomenon in mind when working with different hues.

Colours closer to blue on the colour wheel have a cooler feeling than those that stand next to orange (the warmest point in the wheel). While there is not a definitive cool or warm colour range there is some agreement that red, red-orange, orange, yellow-orange, yellow and yellow-green are on the warm side of the wheel whereas green, blue-green, blue, blue-violet, violet and red-violet stand on the cool half. Whenever in doubt—especially when working with colours that sit in the warm/cool threshold, like yellow-green or red-violet—gauge the amount of red/orange/yellow (warm) or blue/green/violet (cool) that they contain to classify it as one or another.

When you create palettes you will find it useful to learn to see colours as cooler or warmer than others, rather than considering them as categorically warm or cool hues. For example, if we look at the colour red, a hue definitely considered warm, its two neighbours on the wheel, red-purple and red-orange, can be perceived respectively as cooler and warmer. So, if we are interested in working with red we could pair it with red-violet or red-orange in order to build a cooler or warmer colour scheme appealing thus to the mood cool or warm colour groups can transmit.

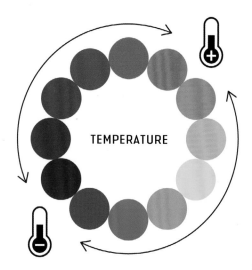

On the right, the golden plastic display with cherries (harvest time!), the dried flowers, the perception of a light-filled room and the presence of red, orange and yellow characterize a definite warm atmosphere. Overleaf, in contrast, the emphasis on blue and green and an overall sense of shadow and freshness (notice how the mint leaves enhance that feeling), determine the cool temperature of both these images.

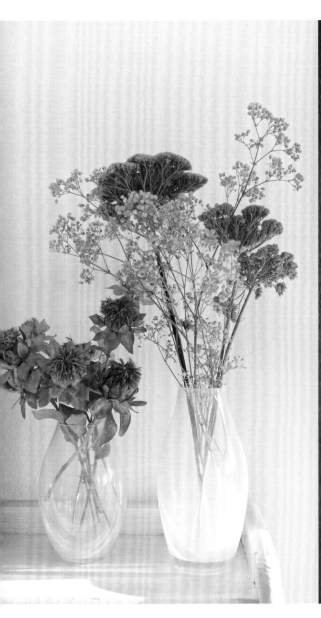
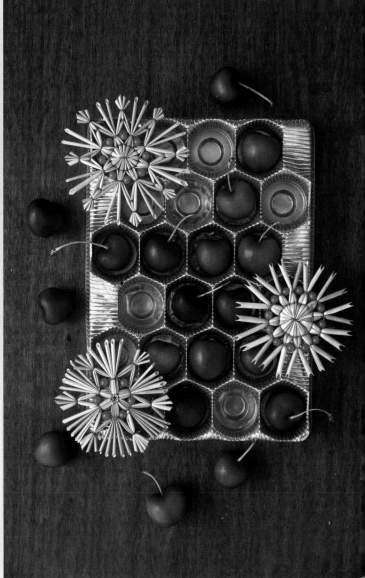

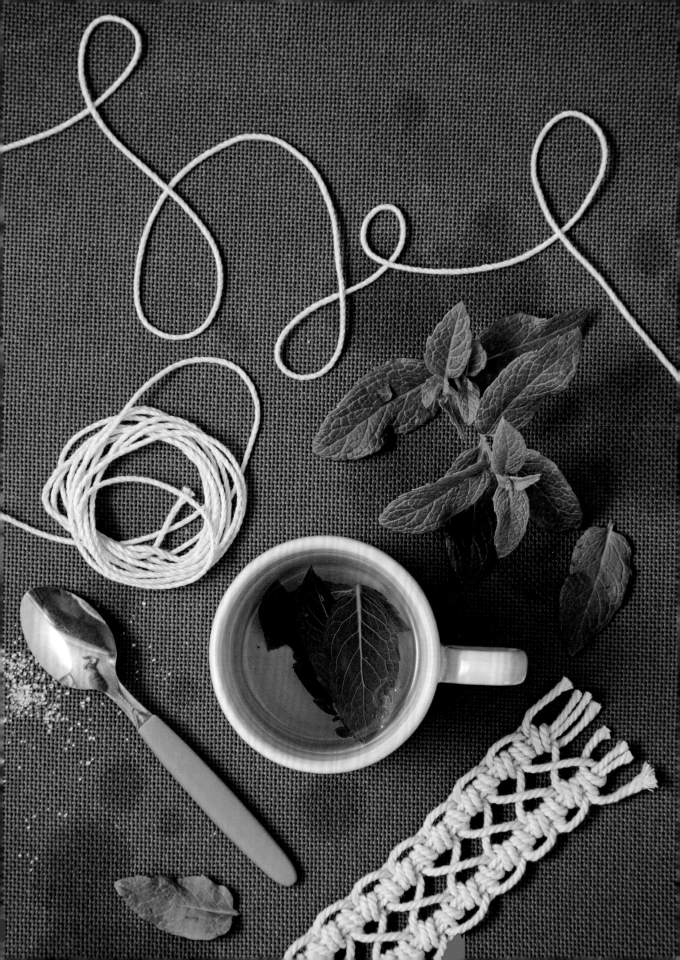

Colour Cards

These colour cards have been devised as a tool for easily identifying the different attributes that each hue can adopt when its value and/or saturation are modified. They will help you visualize your colour combinations instantly and make decisions more confidently.

We have used the twelve main hues from the colour wheel plus three related intensities. Each card is arranged as follows (from left to right): **tint** (light colour version), **hue** (pure colour version), **tone** (muted colour version) and **shade** (dark colour version). We have also included colour cards for warm and cool neutrals and greys organized from lighter to darker. All colours are from the DMC 6-strand embroidery floss colour chart.

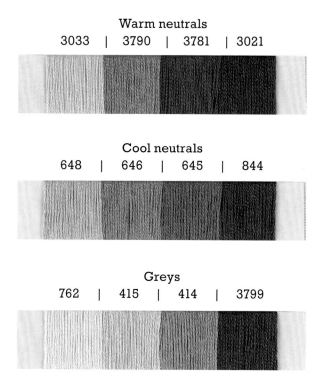

Warm neutrals
3033 | 3790 | 3781 | 3021

Cool neutrals
648 | 646 | 645 | 844

Greys
762 | 415 | 414 | 3799

Make your own colour cards

You can build your own set of colour cards by cutting fifteen rectangles (approx. 10 x 2cm/4 x ¾in each) in white card stock and winding six-strand embroidery floss around each piece; use double-sided tape on both sides of the card to stick the floss down and keep the thread in place.

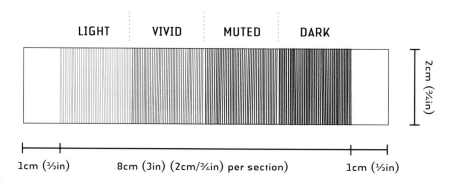

LIGHT VIVID MUTED DARK

2cm (¾in)

1cm (⅓in) 8cm (3in) (2cm/¾in per section) 1cm (⅓in)

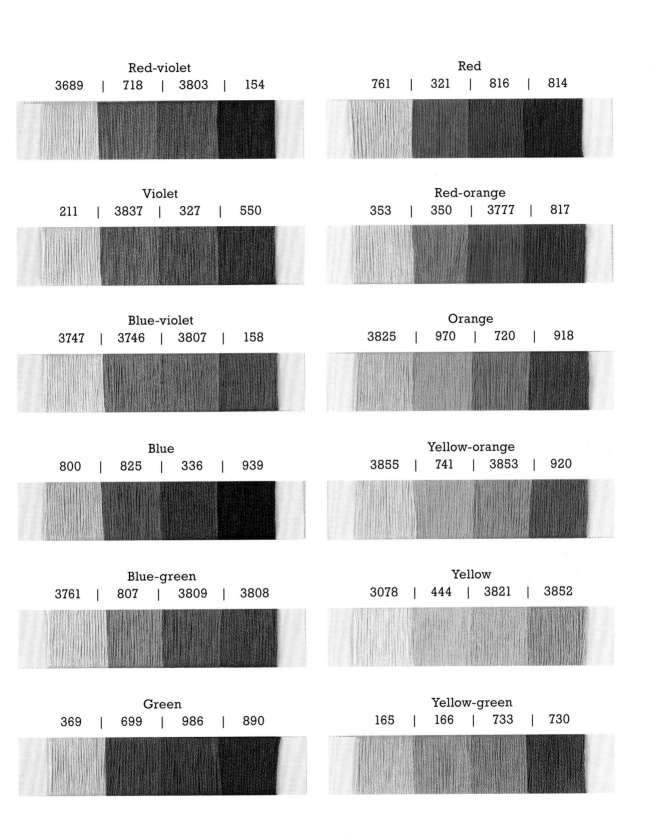

Red-violet
3689 | 718 | 3803 | 154

Red
761 | 321 | 816 | 814

Violet
211 | 3837 | 327 | 550

Red-orange
353 | 350 | 3777 | 817

Blue-violet
3747 | 3746 | 3807 | 158

Orange
3825 | 970 | 720 | 918

Blue
800 | 825 | 336 | 939

Yellow-orange
3855 | 741 | 3853 | 920

Blue-green
3761 | 807 | 3809 | 3808

Yellow
3078 | 444 | 3821 | 3852

Green
369 | 699 | 986 | 890

Yellow-green
165 | 166 | 733 | 730

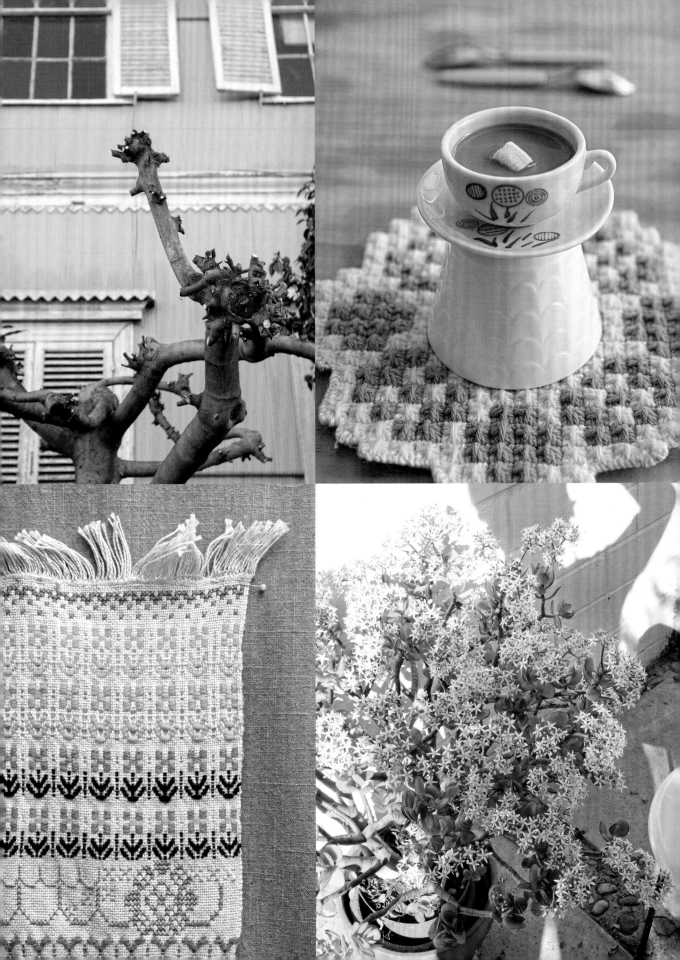

Colour Schemes

If you think of each hue on the colour wheel as a person, then colour schemes are successful relationships that can be initiated between them. Some of these relationships may be explosive or agreeable but they all have something in common: colour chemistry! So **colour schemes are the different relationships that can be established between hues on the colour wheel**. These are distinct ways that colours can combine with each other to create a good rapport whether it is a harmonious or a contrasting relationship.

The colour schemes are: monochromatic, analogous, complementary, split complementary, triad and double complementary and they all have their own traits. Some colour theory authors distinguish other schemes or tweaked versions of these but these six give you a solid starting point.

Colour schemes create an important connection between colours and keep them linked even when they are modified in their intensity (value and saturation) and appear no longer in their pure chromatic state when creating colour palettes.

Working with colour schemes

When working with the following colour schemes remember that the colour wheel can spin from one side to the other revealing any of the twelve colours in the hatched circles. Experiment with all the combinations as you may stumble upon one that is amazing.

Once you grasp the process and feel that your eye is becoming trained, you can always tweak colour schemes to obtain new combinations. For example, if you are using a scheme that considers three or four distinct hues, you can decide to leave one of them out; with schemes that work with two or more, you can consider using the neighbouring hue instead of the corresponding colour pie-slice to get a softer interaction.

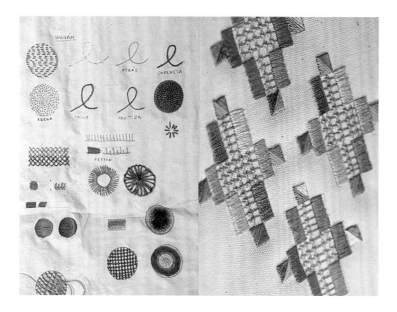

PREVIOUS PAGES
Learning to read colours is crucial in order to make the colour wheel and schemes work for you. Start to colour-train your eye by looking at colours around you and identifying the original hue as well as value and saturation.

FAR LEFT Embroidery samplers should be an opportunity to experiment with colour as well as practising stitches. LEFT A complementary colour scheme is worked twice: red and green with red-orange and blue-green. Hues on the same side of the wheel also create an analogous scheme making it a fail-safe palette.

EXAMPLE: RED

Monochromatic

If we think of colour schemes as types of relationships or conversations between colours, then the monochromatic combination would be a kind of inner dialogue. Monochromatic combinations are built of varying intensities (light, dark, muted) of the same hue. This scheme can give a strong message as it plays with just one colour reinforcing its meaning. It is a safe colour scheme to work with as you are juggling varying intensities of a hue rather than different colours. On the negative side, there is a risk that this scheme can be flat or boring if not worked with enough contrast. A monochromatic combination example can be made from different versions of red such as light pink, flesh pink, true red and burgundy. Even though each shade has its own meaning (light pink is seen as sweet and romantic while burgundy as elegant and rich), when they all work together in the same scheme they emphasize the message of passion, love, power and drama conveyed by the colour red.

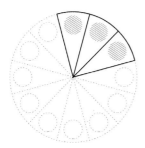

EXAMPLE: YELLOW-ORANGE,
YELLOW AND YELLOW-GREEN

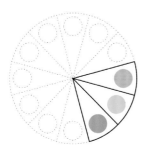

Analogous

This is the 'good neighbours' relationship. Analogous colours are three (or even four) hues that are adjacent on the colour wheel. The proximity on the wheel of these close relatives builds harmonious, united, balanced and agreeable combinations; like a melody. You can't go wrong with this one. The example shows a colour scheme built with yellow-orange, yellow and yellow-green. All these colours share a common colour component (yellow), which not only links them together by a visible undertone but also emphasizes the meaning of the shared hue. Does it look shiny, cheerful and brilliant? Well, that's the colour yellow speaking.

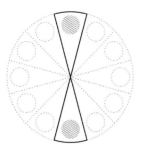

EXAMPLE: ORANGE AND BLUE

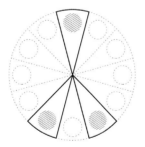

Complementary

Have you heard that opposites attract? Well, this is true for the complementary colour scheme that yields a powerful combination. Complementary colours are opposite each other on the colour wheel and together they make a particularly strong relationship completing and intensifying each other. Whenever you look for the maximum contrast and character in colours, the complementary scheme is your best bet. You can always tone down the effect by using different intensities of the hues or by adding a neutral tone to the mix. For instance, orange and blue are complementary colours as they are located opposite each other on the colour wheel. If used in their pure state they make for a vibrant and striking mix; if worked with different intensities, like a soft peach (a light orange) with navy blue (a dark blue), the colour rapport is still there but transmitting a totally different mood.

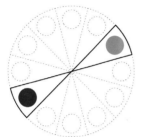

EXAMPLE: RED-ORANGE, BLUE AND GREEN

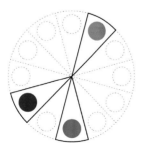

Split complementary

This is similar to the complementary scheme but more relaxed as it is composed by one colour and the two adjacent hues of its opposite. It has the powerful character of the complementary scheme but is more interesting as it is built out of three different hues. Use it for making eye-catching yet sophisticated combinations. In the example, the colour scheme includes red-orange, blue and green. Red-orange is composed of red and orange, both the complementary colours of green and blue. That's why this colour scheme still works with the force of a complementary scheme but in a more subdued manner.

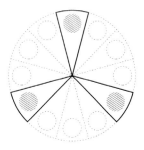

EXAMPLE: RED-VIOLET, BLUE-
GREEN AND YELLOW-ORANGE

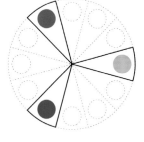

Triad

This is a complex and expressive three-colour scheme. It uses three hues that stand equidistant on the colour wheel (being primary, secondary or tertiary colour trios). As the colours are placed quite far apart from each other it can be a difficult scheme to work with and achieve a cohesive look. A tertiary colours triad can yield a sophisticated combination while the primary colours may offer a more basic and playful mix. The sample shown includes red-violet, blue-green and yellow-orange, all tertiary colours.

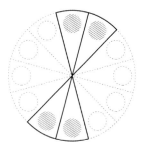

EXAMPLE: VIOLET, BLUE-VIOLET,
YELLOW-ORANGE AND YELLOW

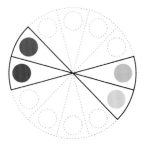

Double complementary

These are two pairs of complementary colours from the colour wheel (they can stand next to each other or equidistantly apart). If one pair of complementaries creates an energetic relationship, imagine what two pairs of opposite colours can achieve together. These four colours are hard to tame so you can play safe by making only one of them prominent and letting the others escort it. For instance, in the shown quartet (violet, yellow, blue-violet and yellow-orange) you may want to choose one of them as your focus hue taking into account the character a primary, secondary or tertiary colour may bring into the act.

Colour Moods

A palette is not just a collection of colour samples but a definite mood statement: the colours used in it describe the spirit within a given atmosphere or space. Is it romantic, funny, dramatic or boring? Or is it mysterious with a hint of tranquility? Colour moods can be broadly categorized into light, vivid, muted and dark according to the attributes of value and saturation of the majority of colours displayed in them. When a palette is, for instance, considered light it means that all or most of its components lie in the lighter range of colours conveying a calming and ethereal feeling, whereas a palette composed of exclusively or mainly darker colours brings a rather mysterious and sophisticated air to it.

The fascinating side of working with colour moods is the very personal atmospheres that can be created by mixing the traits of these main four groups until the desired effect is obtained. For example, to make a romantic palette we could use colours that belong to the light and muted range as we are trying to build an atmosphere that resembles softness, veils, lace (light mood), love letters and memories

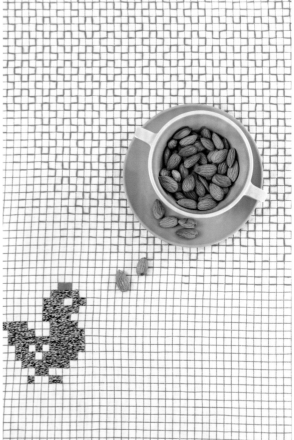

(muted mood). Or we could try a more powerful and luxurious character by adding darker colours instead of the muted ones to the softer colours of the palette.

The colour mood is the personality of your palette. Before working on one you must know what its character should be like. Is it going to be completely classical and traditional? Is there room for a hint of mischief? Sometimes the answer is evident but more often than not our intention might be not clear. Turn to the actual space or context to find some clues.

Is the palette you are working on for a whole room or for a specific object? Bear in mind that objects, accessories and outfits have to interact with the other elements in the area so that might shed a light on the role it should play and hence the most appropriate character you should build for it.

The intensity of light (whether it's lighter or darker) and the intensity of colour (whether vivid or muted) can create the mood. For a strong and well-defined colour mood, keep the majority of colours within the chosen range and add some shades from an opposite mood to avoid a flat look.

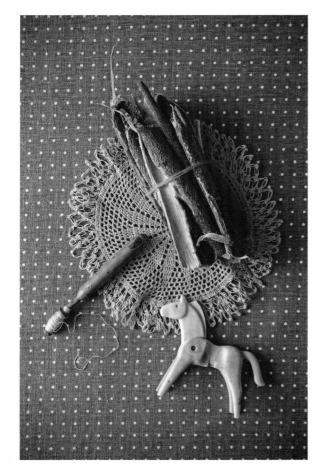

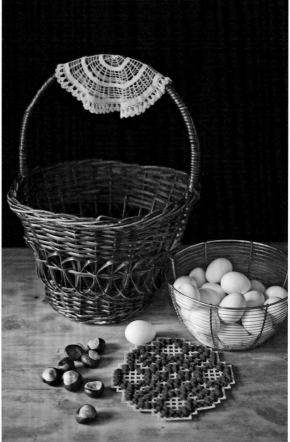

Light Colours

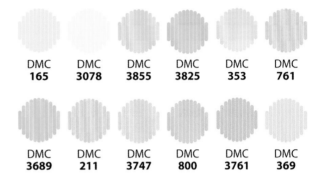

DMC 165	DMC 3078	DMC 3855	DMC 3825	DMC 353	DMC 761
DMC 3689	DMC 211	DMC 3747	DMC 800	DMC 3761	DMC 369

How to recognize them
Imagine how things would appear if you looked at them through a piece of white gauze. All shadows are lightened and everything appears softened, bland and tranquil. It is the world of pastels and tenderness, the realm of white with a hint of colour. White reflects light and creates delicately luminous atmospheres.

What colours?
Vanilla, lemonade, light yellow, peach, apricot, soft pink, lilac, pale blue, aqua, aquamarine, light green.

How are they perceived?
Soft, calming, soothing, relaxing, mellow, sweet, ethereal, fluffy, misty, veiled, gauzy, milky, silvery, pampering, romantic, loving, innocent, cherubic.

What are they associated with?
Clouds, baby, nursery, cotton candy, meringue, cream, frozen yogurt, fleece, gossamer, veil, lace, blush, foam, dough, custard, mother of pearl.

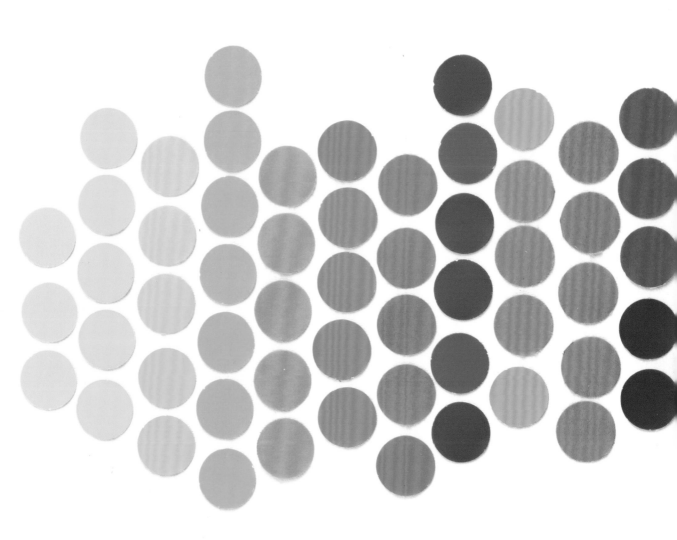

Vivid Colours

VIVID

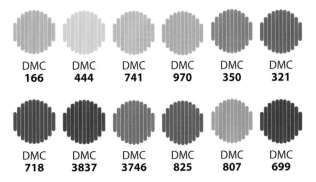

| DMC 166 | DMC 444 | DMC 741 | DMC 970 | DMC 350 | DMC 321 |
| DMC 718 | DMC 3837 | DMC 3746 | DMC 825 | DMC 807 | DMC 699 |

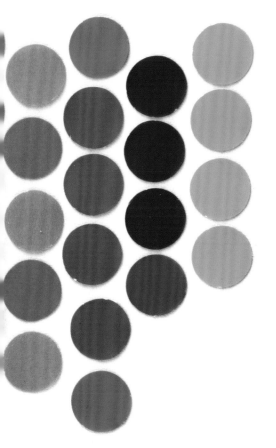

How to recognize them

Vivid colours have a fresh, shiny, new appearance, as if fresh out of the paint pot. They represent the most true and pure essence of a colour, without any undertones or casts and they will mostly coincide with the general sense of what a given colour looks like. Vivid colours are more vibrant to the eye so they will probably be the first shades to grab your attention when looking at a colour chart or buying materials (yarn, embroidery floss, tapes, papers).

What colours?

Bright yellow, tangerine, bright orange, salmon, coral, bright red, bright pink, fuchsia, electric blue, turquoise, emerald, bright green, lime.

How are they perceived?

Vibrant, passionate, exciting, alive, young, noisy, festive, happy, outgoing, striking, energetic, invigorating.

What are they associated with?

Rainbows, jelly beans, fruits, popsicles, colour wax-pencils, paint, children, celebration, entertainment, carnival, dancing, gemstones, glitter, synthetic textile fibres (polyester, nylon, acrylic).

Muted Colours

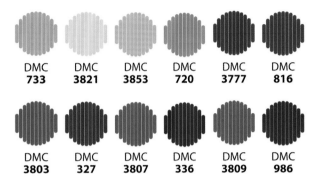

DMC 733	DMC 3821	DMC 3853	DMC 720	DMC 3777	DMC 816

DMC 3803	DMC 327	DMC 3807	DMC 336	DMC 3809	DMC 986

How to recognize them

If vivid colours have a fresh just-been-opened appearance, muted shades seem to have been out for a long time. It is the tone of sun-faded fabrics, worn prints, over-washed garments or things that have a layer of dust on them. Muted colours are all about past times and nature and introverted and thoughtful personalities.

What colours?

Straw, old gold, bronze, curry, caramel, copper, saffron, rust, brick red, dusty pink, mauve, lavender, teal, khaki, sage green, fern green.

How are they perceived?

Tranquil, placid, natural, organic, rustic, worn, dirty, faded, decayed, dusty, dry, dense, intellectual, boring, dull.

What are they associated with?

Nostalgia, memories, smoke, ash, natural textile fibres (wool, linen, organic cotton), autumn, dry leaves and flowers, pebbles, sand, spices, clay, adobe, bricks, sepia photography, vintage postcards, vintage clothes.

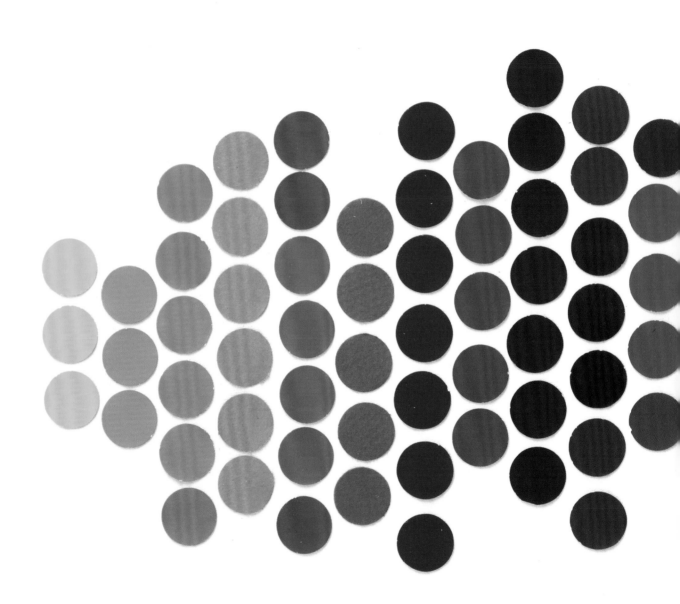

Dark Colours

DARK

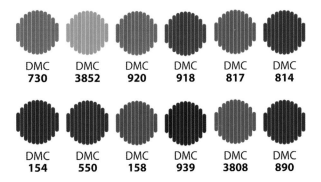

DMC 730	DMC 3852	DMC 920	DMC 918	DMC 817	DMC 814
DMC 154	DMC 550	DMC 158	DMC 939	DMC 3808	DMC 890

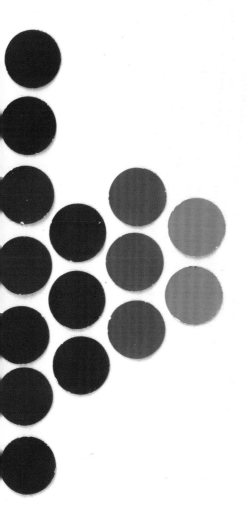

How to recognize them

When natural light disappears, everything looks deeper and more intense and we can barely distinguish their original colour. So imagine what that dark colour you are seeing during the evening might look like when viewed at midday. It is also fun to imagine the effect of water on different materials and how when soaked they turn into a dark mood: a splash of water on a dress, watering dry soil, the look of wet hair after a shower.

What colours?

Honey, henna, auburn, terracotta, burgundy, beetroot, raisin, deep purple, navy blue, olive green, dark green.

How are they perceived?

Mysterious, serious, enigmatic, mystic, rich, elegant, luxurious, complex, sophisticated, traditional, historical.

What are they associated with?

Adulthood, shadow, night, storm, underground, underwater, velvet, coffee, chocolate, wine, coal, black-and-white photography, opera, jazz, classical music, theatre, museums.

Colour Roles

Assigning roles to each colour within a palette is an essential step in fine-tuning the overall mood, communication and appearance you want to achieve. Just as in any play, novel or film we find leading and supporting roles; in a colour palette we distinguish three distinct parts: dominant (or main) colour, subordinate (or background) colour and accent colour. These roles are a reflection of the proportions established among the colours in terms of their importance and/or expanse within the palette.

When you create palettes for embroidery projects, there are two ways of assigning colour roles according to the importance the background fabric may have in the overall piece.

Passive backgrounds
Most of the time, embroideries are worked on a base that it is passive in its colour: white, ecru, beige or light grey are common background colours. In this case, the visual quality of the piece relies on the colours of the floss which are organized in the palette according to their importance (appearing in the most essential or significant motifs) and expanse (area covering). The dominant colour is the shade that will take the leading role: visually it is the strongest colour in the palette and conveys the primary message. It will cover most of the embroidery motifs and use the largest colour slot in the palette. The subordinate colour appears second in importance and extends in the palette for roughly half the area of the dominant. The accent colour is the narrowest in area coverage—usually appearing in a small but significant detail of the object—but it can be as striking (or even more) as the dominant colour. The accent colour stands out from the others as

it usually exhibits a distinct attribute: it may be dark if the others are light or medium toned, it may be vibrant if the rest are muted or it may be a warm colour among cool ones and vice-versa.

Active backgrounds
The other option is when the embroidery includes a coloured background fabric that plays a more active role in the piece. Unlike previously, here the subordinate or background colour extends in the largest slot of the palette but still keeps its subdued importance in terms of colour intensity and attention. The dominant colour, although it shares the second largest slot, maintains its predominance as it is probably going to cover a significant area or motif in the total project; the accent colour continues to hold the same role.

The 24-colour slot frame
In this book we have arranged the palettes in a 24-colour-slot frame assigning fourteen slots to the dominant colour, seven to the subordinate and three to the accent which represents a suggested proportion among the colour roles. We recommend that you start with this 24-slot frame and as you become confident, assign a different number of slots to each colour according to what works best for your project.

Creating a range of colours
It is important to understand that having three roles does not mean that the palette is only restricted to three colours. On the contrary, once you have decided the roles, you will be able to add other variations within each role in order to achieve a depth of range where needed. So if you have assigned fourteen slots for the dominant role, you can open up this colour by using the slots inside to accommodate

different values for the chosen colour without compromising or altering radically the expected mood of the palette. This is particularly helpful when stitching as it can enrich the details and dimension of the motif and overall design.

When it comes to embroidery palettes, you can open up the dominant and subordinate colour up to four sub-colours and the accent colour to three, but you can always adapt these quantities to the requirements of your design. Each sub-colour can sit on a varying number of slots according to its importance/expanse in the piece.

Ordering the colour slots

The order of the colours slots is also significant and affects the whole look and feel of the palette as it contributes to a sense of fluidity and connection among them. The main goal of building a palette is to present the colours in the most harmonious and inspiring way for the project: the transition from one slot to another should occur naturally and effortlessly and it should serve also as a map to display the preferred position of each colour with regard to the others.

PASSIVE BACKGROUND FABRIC

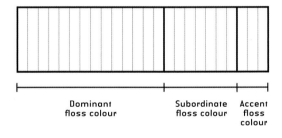

Dominant floss colour Subordinate floss colour Accent floss colour

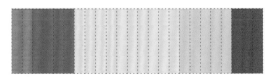

White or neutral background fabric

DOMINANT COLOUR: Orange (muted and light)
SUBORDINATE COLOUR: Blue (muted and light)
ACCENT: Orange (vivid)

ACTIVE OR COLOUR BACKGROUND FABRIC

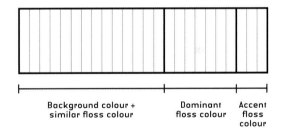

Background colour + similar floss colour Dominant floss colour Accent floss colour

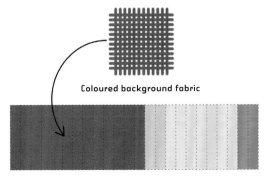

Coloured background fabric

BACKGROUND COLOUR: Blue (muted and light floss)
DOMINANT COLOUR: Orange (light)
ACCENT: Orange (vivid)

Arranging the colour slots

In order to achieve a seamless blending consider organizing the colour slots according to one or more of the properties of colour: hue, value and/or saturation. The sequence can range from one extreme to the other (from the lightest to the darkest, from the most vibrant to the most muted, etc.) or distribute the change in properties in a radial fashion (the centre of the palette holds one property while both ends shift to the opposite quality).

The cotton muslin makes an unobtrusive (passive) and neutral background to the colourful embroidered pattern on this cell phone pouch. The triangles build their own colour dynamic and are only slightly influenced by the warm cast of the fabric.

The blue background takes an active role as it holds more colour information than the neutral palette (ecru, black) of the embroidered sections becoming thus a defining element inside the piece. Imagine how this same embroidery would lose much of its essence if worked on a passive/neutral background.

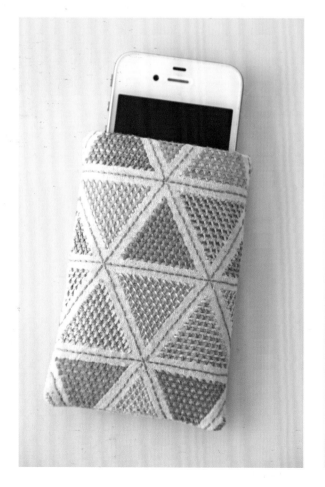

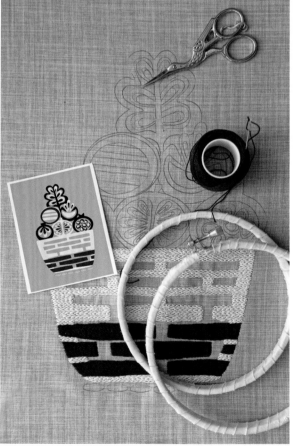

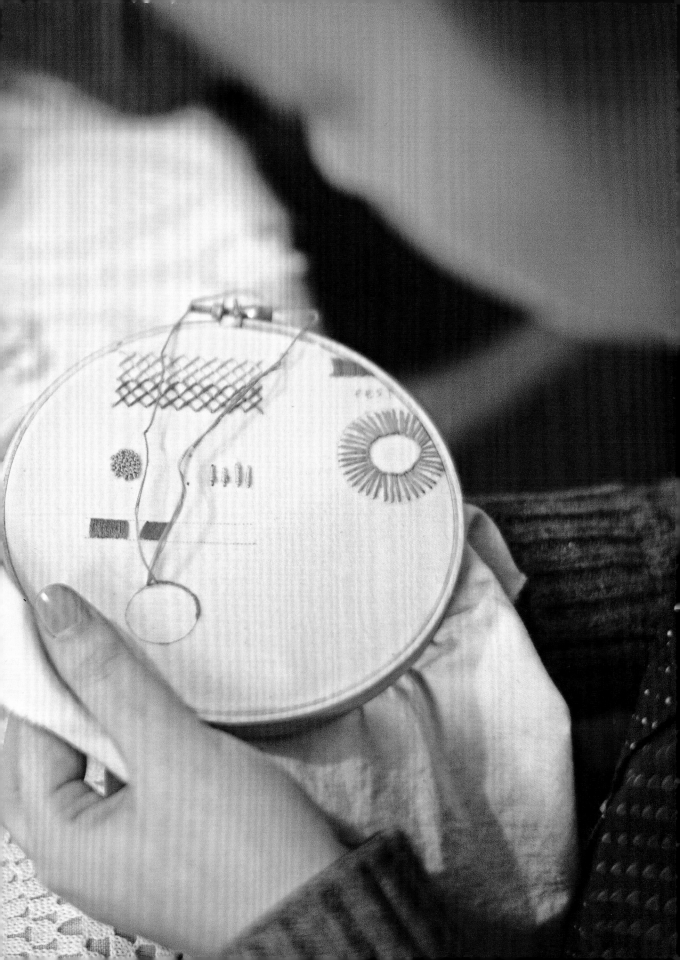

Creating a Colour Palette Using Colour Theory

So now that you have learned the basics of colour theory, you are ready to start experimenting and creating wonderful combinations for your embroideries or other projects. This exercise is outlined step by step so that you can fully understand the process and gain confidence for future practice. Keep in mind that this example is just *one* of the many possibilities that can be achieved by colour theory and that you are free to take a different direction at any stage. All these steps are part of an iterative process so you may find yourself coming back and revising previous decisions and exploring different options until you achieve your own perfect palette.

Step 1 — Choose your colour

We have chosen a **dark straw** colour embroidery floss (DMC 3852) for this example. Remember that you can pick whatever colour you like or feel is the best alternative for your project. What is important is to be able to recognize the colour you are starting with and allocate it to one of the twelve basic hues on the colour wheel. In this case, our selected colour is a dark version of **yellow**.

DARK STRAW COLOUR
(DMC 3852)

Step 2 — Choose a colour scheme

On pages 20–1 we described the different traits that each colour scheme can contribute to a given colour palette. After some practice you may be able to decide beforehand which of the schemes would work best for your project but as this is the first attempt, we will try all of the possible combinations (nine in all).

We will use the floss colour cards to visualize a broader range of colours so when we, for example, match yellow to violet in a complementary colour scheme, we will know that violet is not the only option but we also have lilac or deep purple to work with. This means that combining, for example, dark straw with lilac will yield the same contrasting spirit of the yellow-violet complementary colour scheme but the difference lies in the colour mood (see Step 3). Go through the different colour groups and try to imagine some of the possible combinations.

After examining the available combinations we have decided to pick the **triad scheme**. Why? The input colour (dark yellow) is a toned down and discrete shade and while we like it in itself, we would rather create a palette that feels a bit playful and more complex but still retains the understatement of the original source. The triad scheme offers some of that complexity and invites red and blue to build a lively palette.

POSSIBLE COLOUR PALETTES USING DARK YELLOW

MONOCHROMATIC

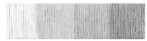

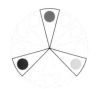

ANALOGOUS 1
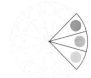

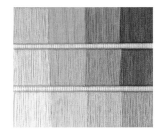

ANALOGOUS 2

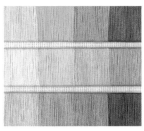

ANALOGOUS 3
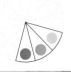

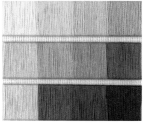

COMPLEMENTARY
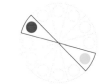

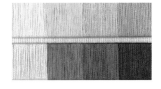

SPLIT COMPLEMENTARY
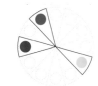

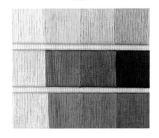

TRIAD
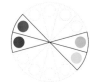

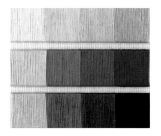

DOUBLE COMPLEMENTARY 1
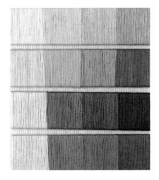

DOUBLE COMPLEMENTARY 2
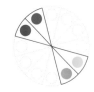

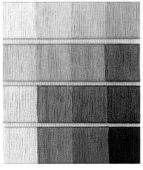

Step 3 — Choose the colour mood

We want to keep an **understated** nuance in our palette. That means that vivid colours will play a small role in the combinations, just the minimum amount to keep things cheerful. Therefore, we will lean towards using colours that are light, muted and dark.

Also consider possible conflicts between colours. Yellow and red are definitely warm in their temperature and when used together, red appears stronger and more noticeable. So, in the spirit of maintaining the palette in a calm and sober mode, we chose pink to mark the presence of the colour red in the scheme. In this same line, we included all four versions of blue as a means of counteracting the other two warm colours and making the most of the sense of tranquility, silence and solidity that

blue conveys. As for the yellow options, we are keeping the light, vivid and dark versions. We have left out the muted yellow because when compared with the dark straw yellow, they appear quite similar and it even looks like the muted one drags the dark yellow down. Therefore the muted yellow is left out and we have a good contrast between the input colour and the light and vivid yellow. Thus, we have built our project colour chart with eight colours that feel true to the idea of an understated yet playful palette.

Remember that when selecting colours for your chart you don't have to be limited to the colours resulting from your chosen colour scheme. You can add white, black, grey and neutrals into the mix thereby boosting the character you are trying to achieve.

TRIAD COLOUR SCHEME

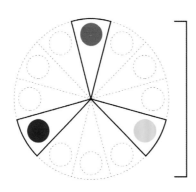

COLOURS REFERENCED FROM SCHEME

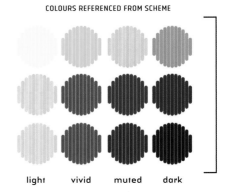

YELLOW

RED

BLUE

light vivid muted dark

PROJECT COLOUR CHART

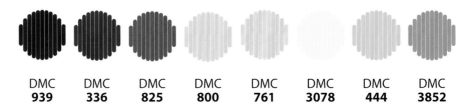

| DMC **939** | DMC **336** | DMC **825** | DMC **800** | DMC **761** | DMC **3078** | DMC **444** | DMC **3852** |

Step 4 — Choose the colour roles

This stage of assigning colour roles can take a long time as the possible combinations are almost endless. From a defined colour chart you can create several palettes for different projects that nest under the same mood. You could, for example, stitch a group of cushions creating a unique palette for each one yet achieving an overall cohesive collection as they are all connected by the same colour chart. Don't get discouraged if you can't make up your mind with so many options—it can be fun to play and experiment with the different alternatives!

On the right we have chosen three background colours: a passive background (beige) and two active ones (pink and muted blue). When you start with the colour of fabric, decisions are made easier as the available options are limited. Consider whether the base is light or dark as that should guide you regarding the contrast or uniformity you want to achieve with the floss colours.

PASSIVE BACKGROUND

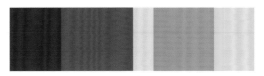

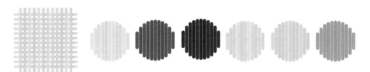

Beige background fabric

Embroidery floss colours

ACTIVE BACKGROUND VERSION 1

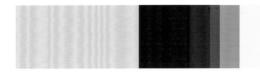

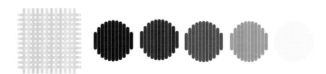

Pink background fabric

Embroidery floss colours

ACTIVE BACKGROUND VERSION 2

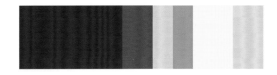

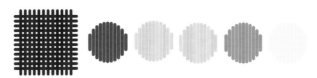

Muted blue background fabric

Embroidery floss colours

Feeling
Colour

We can capture colours from our experience—words, memories— or perhaps our eyes rest on an object or image and you know—or more accurately, feel—that that these are the *exact* colours you are looking for.

The world is an enormous colour gallery waiting to be discovered and used in its infinite possibilities. You can capture a group of colours from one context and transfer its spirit and beauty to a totally different place: you can stitch that marvelous colour combination you see in your garden or from a sunset landscape or vintage fabric to your own embroidery.

This chapter shows you how to capture colours from different sources. These straightforward steps clarify what is often an instinctive process so you will be able to transform all the beautiful colours you see into palettes that you can apply to any piece.

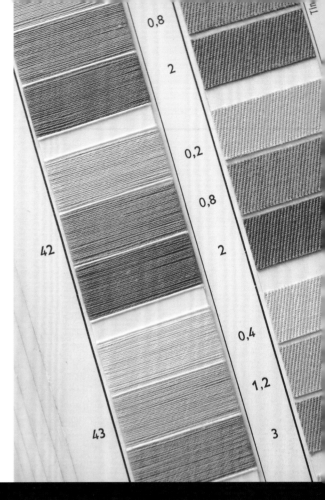

Words as Inspiration

One of the easiest ways to create a colour palette from scratch is to allow words and phrases to call on images and visual ideas that can help you choose the right colours for your project.

Let your mind wander and write down all the words that come to your head. Ideally they should be nouns and adjectives that resonate with you, that make you feel comfortable or that evoke dreams or memories. Choose one of your ideas and

NORTHERN LIGHTS

Inspired by the aurora borealis, this palette brings together the depth of the night and the magic of vivid colours with starry metallic sparkles.

Key words to search: aurora borealis

Colours: fuchsia, purple, cobalt blue, azure, light green, silver

DMC 772	DMC 603	DMC 601	DMC 333	DMC 158	DMC 3843	DMC E168

write a short sentence using one noun and one adjective. Use this phrase to do an image search online. When the phrase is quite specific for the intended mood you should get similar results and the colour palette should pop easily in front of your eyes. If the phrase is too wide or generic, you might get different results and the colour palette can be harder to make out. Try new words and different combinations until the image search brings up the type of palette you had expected.

TROPICAL SEABED

A dive into the colourful and dazzling world of the tropical seabed.

Key words to search: tropical sea, underwater marine sea, neon fish

Colours: orange, cobalt blue, azure, navy blue, neon green, copper

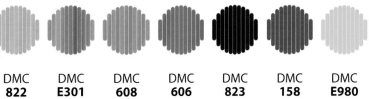

DMC 822	DMC E301	DMC 608	DMC 606	DMC 823	DMC 158	DMC E980

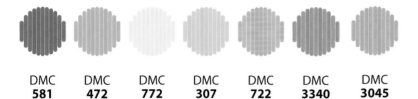

| DMC **581** | DMC **472** | DMC **772** | DMC **307** | DMC **722** | DMC **3340** | DMC **3045** |

NIGHT MOTH

The mystery and glow of moths at night, golden dust, the clink of jewellery and high heels.

MELON SHERBET

A refreshing melon sherbet with a pinch of citrus juice on a hot summer day, the soothing effect of pastel colours.

Key words to search: melon cantaloupe, melon honeydew, fruit sherbet, wafer

Colours: apricot, orange, yellow, light green vivid and muted lime green, sand

| DMC **3045** | DMC **3078** | D E3 |

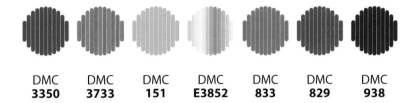

| DMC **3350** | DMC **3733** | DMC **151** | DMC **E3852** | DMC **833** | DMC **829** | DMC **938** |

ey words to search:
oth, night butterfly,
t Deco jewellery,
tterfly brooch

olours: light and
uted yellows, black,
eige, gold

| C | DMC **310** | DMC **318** |

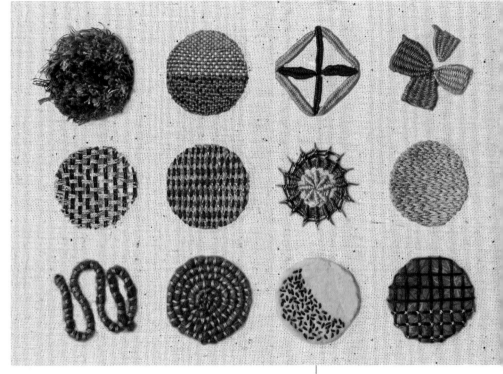

FRENCH CONFISERIE The dream of macaroons, chocolates and sumptuous golden lettering on a cake box from a *confiserie* in Paris.

Key words to search: *confiserie*, patisserie, vintage, macaroons, Paris

Colours: muted pink and fuchsia, browns, gold

How to Find Chromatic Sources

When you realize that everything around us is an infinite source of colour, you won't stop searching for new combinations! Let your eye roam among things, people and places until you stumble upon beautiful colour stories. Your eye will identify them and direct you toward a particular spot that feels harmonious in its colouring. There are no right or wrong colour palettes; it is about choosing the one that best resonates with what you want or need (and it can be different to what your mother and friends consider 'nice' colours).

When you are searching for colours, squint your eyes so the edges of things are blurred and reduced to coloured patches. Explore and switch between different scales—look for tiny things (like inside a flower) as well as large open spaces (like a theatre). Use your gaze as a cropping tool focusing only on what is essential to the colour story, leaving aside anything that feels foreign or unconnected to it.

At the end of this chapter you will find nine palette proposals extracted from some inspiring sources. They are arranged in three groups according to their scale—**things** (small scale), **scenes** (medium scale) and **places** (large scale)—to guide your colour explorations.

Small scale (Things)

Things (all the stuff around you) become one of the richest groups for sourcing colours. There is a potential colour story in your box of ribbons, a stash of fabrics, the vintage dress you bought but still haven't worn, in your make-up palette, the eyes and fur of a cherished pet, the beautiful outfit of a stranger in the street and so on. Clothes and commercial products can turn into great colour studies as they are always developed by designers who pay particular attention to creating palettes. Don't overlook things that apparently have too few colours to build a whole story—in the following pages you will learn how to capture a broader range of colours even if they are not immediately visible.

Medium scale (Everyday life)

When hunting for colours at a medium scale, look out for scenes of everyday life. Scenes can be harder to grasp compared to things as there are more factors involved in the creation of an inspiring setting: your eye should detect a connecting thread that links objects, people, place and lighting in a consistent story. Have you ever looked over the table where you were making something or at a spot in your backyard after doing gardening and felt visually stimulated? It is likely that such spots have some expressive colour potential that your eye is detecting. Home decoration magazines, shop windows and traditional artwork (as they depict a particular scene) can provide infinite colour inspiration. Also, keep an eye on how people can unexpectedly change and enrich a given scene with their unique colouring (skin, hair, make-up, outfit, accessories)—have you ever noticed how your friend's nail polish matches the surroundings?

Large scale (Places)

The third scale is the big picture: the streets, neighbourhood, open spaces, landscapes, the ever-changing sky. When out and about explore the places you habitually move through with fresh eyes. Does that lady's umbrella blend beautifully with the building behind? Or does the grocery shop sign look as never before with that deep cloudy sky behind it? Snap a picture and take that colour story with you!

How to Capture Colours

Once that you have collected some chromatic sources, it is time to sharpen your eye and identify and register those inspiring colours that will bring your palette to life. This process can be done manually (that is, just by relying on your eye sensitivity) or helped by digital tools. Once you have tried both methods, you will realize that you have more control over the results when you do it by eye rather than by an automated operation.

Why do you like the colour?

Look at your image, object or material and ask why is it that you like it. Different people may connect with an inspiring image for different reasons due to their own backgrounds or personal experiences, so it is important that you notice what are the details that really attract you.

Write down all the ideas that come to mind as these will become valuable clues in the upcoming stages. Does it remind you of something (memories, person, movie, place, etc.)? Are there any sounds, smells or flavours that spark from it? Remember that we are trying to grasp all the colour information by means of our senses so every perception you can draw on to help is of benefit.

Look at the photograph opposite with the blue tablecloth and mint leaf tea. Are you drawn to something in particular in this scene? Are any of your senses aroused by the colours or elements displayed? Perhaps the mint leaves and the blue tablecloth with its scattered sugar will provoke a recognizable taste and cool sensation. The water stains on the fabric and the shadowed light also contribute to the impression of a cool haven on a hot summer day. Some people may also relate to some of the secondary elements in the image like the macramé sample, the cotton twine and the plastic spoon handle and connect to the simple and unpretentious spirit they convey.

As you try to understand the atmosphere of your inspiring image, answering these questions will guide you when choosing the final colours for your palette. If, for example, the cooling effect appeared as a strong theme in your analysis, then your colour decision will be strongly influenced by it: cool colours will have a dominant presence in your palette and appear in a broad range of light, mid-toned and dark shades so as to convey that shadowed and soaked feeling.

Identify significant colours

Next, make a visual inspection, identifying the most relevant colour areas in terms of significance and expanse. Usually colours detected by **significance** will be those present in the focus point of an image (that is, the element that defines the essence or main story of the picture) or the one that resonates with deepest meaning to you. Colours identified by **expanse** correspond usually to the background or larger areas of the examined source: the colour of the sky, a wall, a tablecloth, a backdrop, etc. While this may seem a bit too obvious, a visual practice sequenced like this helps to train a finely-tuned eye that in time can beat any algorithm-based colour chart.

REGISTERING THE CAPTURED COLOURS

BLUE
(background tablecloth)

GREEN (mint leaves)

ECRU AND BEIGE
(cotton twine, macramé piece and cup)

TAUPE
(metallic part of spoon)

AQUA
(spoon's plastic handle)

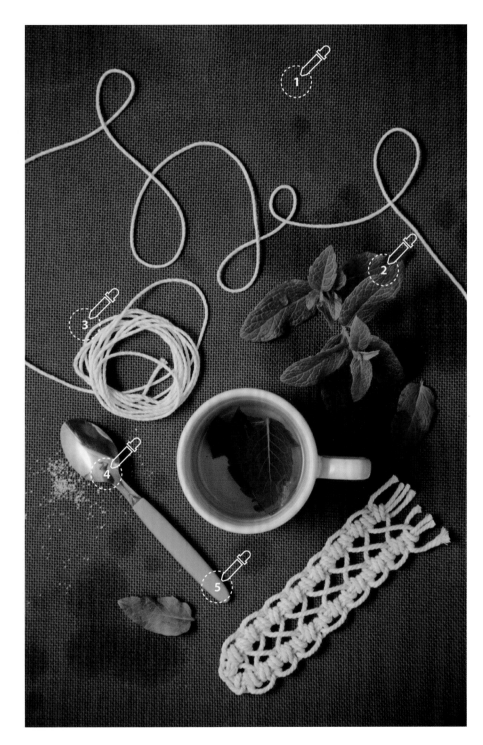

Capture broad tonal ranges

Pull as many colours as you can from your source and organize them by sampling point. There may be some materials or objects that appear as solid colours yielding apparently less colour options. Don't be fooled! Take a closer look to discover the richness of its textures, highlights and shadows. How does that solid colour look when it is in bright light? Or in the shadow of the crevice? If you look carefully you will be able to capture a broad tonal range of an otherwise single colour.

Look how the tablecloth in the photograph on the previous page (which is present both as significance and expanse) can appear as several shades of blue from different points: the lit-up areas, the darker corners, the wet spots and the shadowy intersections of the woven fabric. So, instead of trying to merge all these blues in a single representative shade, collect *all* the colour variations for a richer chart.

Record the significant colours

The next step is recording all the significant colours that you detect on to a colour reference sheet. This can be done by using colour papers or paint chips on a white piece of paper; you can also try mixing gouache and render the colour samples with paint. Alternatively, if you are working with your computer, you can fill in cells or rectangles with the captured colours in a productivity software; if you are familiar with photo editing software, you can use the eyedropper tool to collect the RGB colour formula of the analyzed spot. Don't forget that colours viewed on screen cannot be reproduced accurately on paper so, for the following stage, you may need to reference the colours on the screen of your computer or device or make good quality prints that closely resemble the original samples.

The aim of recording the colours is to build a colour inventory of the image you are working with.

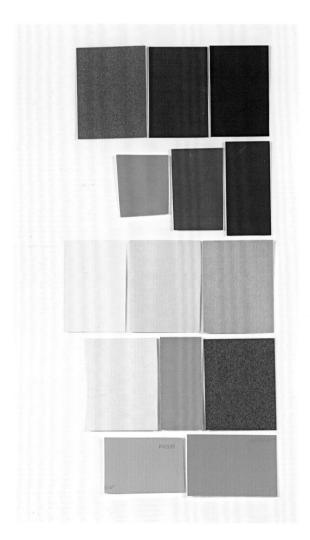

Arrange the samples by colour family or temperature and organize them in light-to-dark or vivid-to-muted sequences so as to create a visual colour panorama that you can always turn to later.

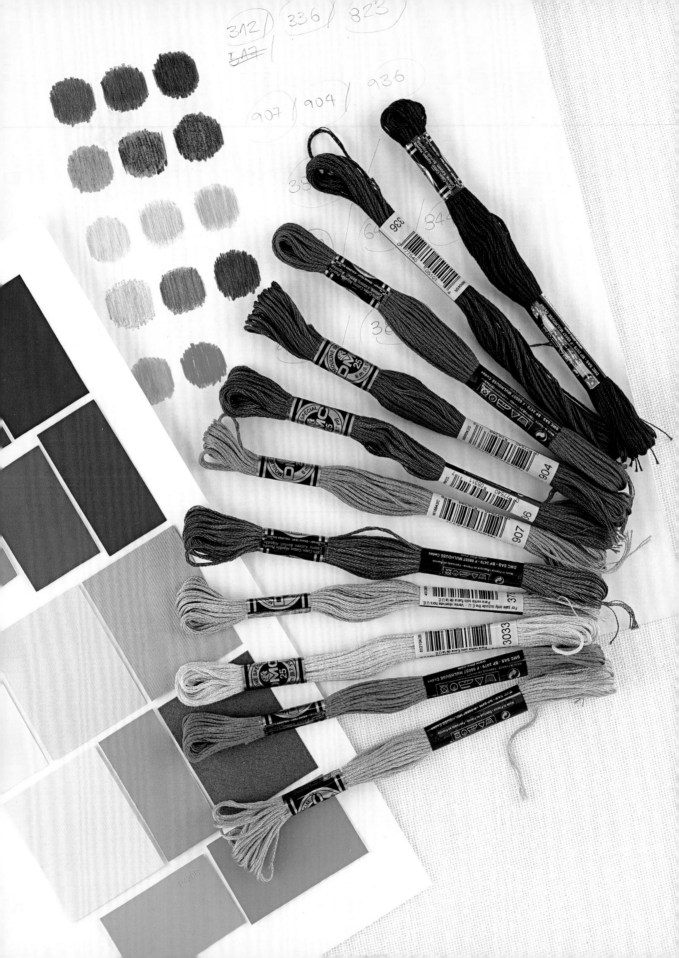

How to Use Digital Resources

Digital tools can be an excellent way of aiding your work with colours if you use them just like that—like a helping hand rather than an automated device for replacing your creative process. They make a great starting point especially if you feel stuck in a palette-maker's block.

Digitize your colour source

When working with digital tools you will need to have your colour source (image, material, etc.) digitized in order to be able to work with it. A jpg or png image file are the best formats for this. If your source is already in a digital format (that is, it is an image from the internet or from your camera/mobile phone gallery), chances are it will accurately render the colours you are expecting to capture. The trouble comes when converting real-life material into a digital image: colours can be significantly modified according to the lighting, background and camera settings thereby yielding distorted colouring. Scanning a material or object can be a good alternative as it offers a cleaner and less colour-contaminated output although it can lack the mood conveyed by the surroundings.

Use filters to create colour patches

Some people find it easier to capture colours after they have applied filters to the image that blur the contours and generate pictures that look more like patches of colour than recognizable shapes. All photo editing software include filters like blurring or pixelating that can transform your image into a colour map that makes it simpler to visualize the colours in it. Tweak the settings until you no longer identify the element's edges and see them simply as colour spots instead. Save your new image to your computer and start working on the colour registration step (see page 62) using pencils, paint chips or your preferred method.

The example opposite was pixelated using Pixlr Editor until all the shapes disappeared into colour squares. However, there are other editing options available; search for 'online photo editor'.

Adobe Color CC

A more sophisticated online tool is the Adobe Color CC platform that not only works as a deposit of fine colour palettes but offers the possibility of uploading your preferred image and extracting the most important colours for your use. For this example we will use the photograph shown on page 63. See how it recognizes two blues (tablecloth), two greens (mint leaves) and one aqua shade (spoon) as the most significant colours in the picture. We may agree with this selection but keep in mind that when you prioritize one element from the image over another, you are bringing your own unique stamp to the resulting palette. You can always re-arrange the sampling points until you get your desired colour combination.

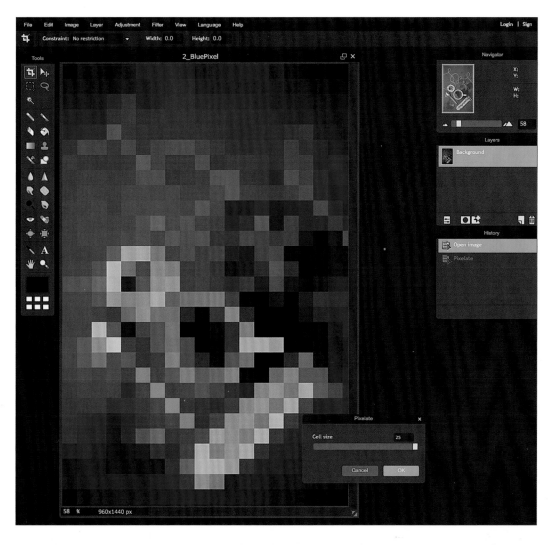

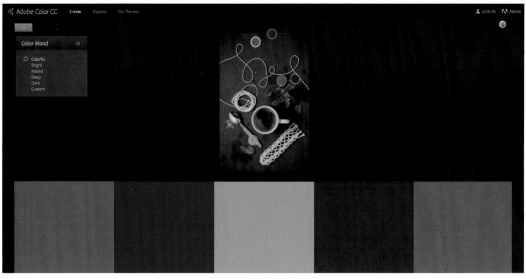

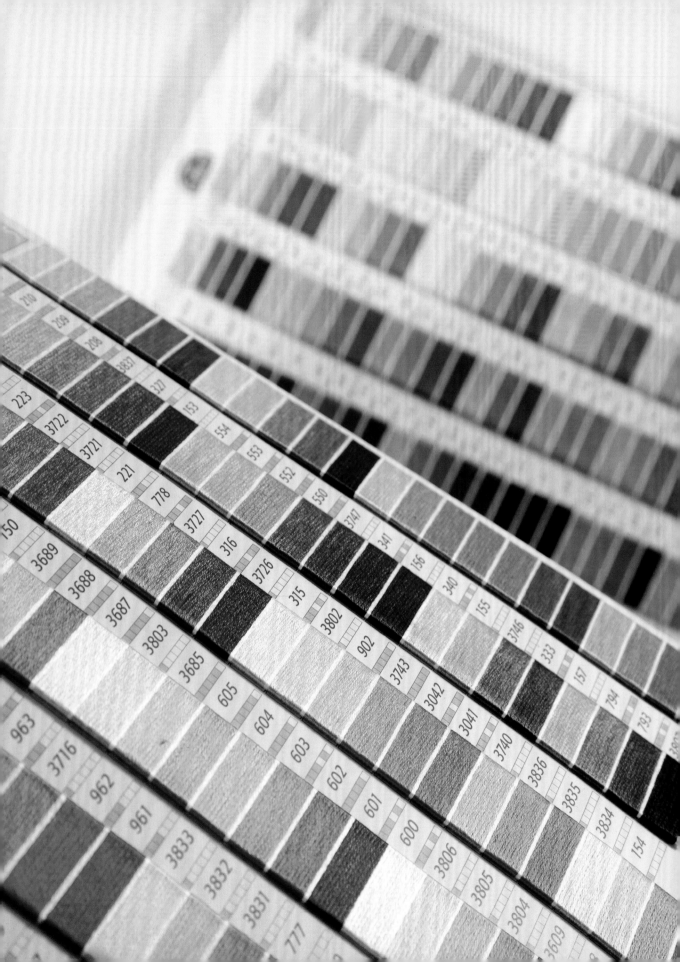

How to Build a Colour Chart

After capturing and registering what you consider to be the most significant colours from an image or object, you need to decide which ones you are actually keeping to build the colour chart for your project.

Start by referring to the notes you wrote down in the previous step. What is the mood that you are attracted to and want to convey with this selection of colours? Continuing to use the photograph on page 63, if you like the refreshing atmosphere, you would pick all of the blues and greens and leave out some of the warmer tones from the cotton twine macramé and metallic sheen. Alternatively, you could build a more balanced colour chart and keep a similar quantity of cool and warm shades to retain some of the cool mood along with the cosy feeling provided by the warm neutrals. Keep an eye out for colours that may be very similar to each other and discard one of them; you should only keep those colours that truly contribute to the mood and avoid duplicate shades.

Using a commercial colour chart

After you have chosen your colours (twelve should be sufficient to make a solid colour chart) comes what can be a challenging and painstaking process: that is, translating your selected colours into defined shades from a commercial colour chart. Up to this point we have made an effort to pick just the right colour, not a bit lighter, not a bit darker. But when we face the limited colour range of our preferred medium or material (embroidery floss, yarn, fabrics, trim, etc.), we may need to adapt the original choices to those that seem the most similar to what is available.

While this process can be done immediately after identifying the colours from an image, the value of recording the colours in a reference sheet first is that it documents your colour selection without any compromise due to the range limitations of the material. This allows you always to refer back to the original source if you wish to use these colours in another project with a different material or medium.

Material influences colour

Materials render colours differently according to their intrinsic properties: synthetic fibres, such as 100% polyester machine embroidery thread, can reproduce the widest range of colours including bright neons and specialty metallic finishes, whereas wool due to its more textured fibre surface (the shaft of wool fibre is covered by scales) displays colours in a more toned-down manner (see below). Mercerized cotton—thanks to a chemical process that boosts lustre and strength in the fibre—

is able to render colours which are bright and saturated in colour.

The most renowned brands of cotton embroidery floss (DMC, Anchor) and wool thread (Appletons) offer over 400 colours. And while that sounds like a lot to choose from, it is likely that you may not find the exact shade you had planned and you will need to adapt your colours. When doing this, keep in mind that you want to maintain the intended overall mood and therefore you may need to adjust not just the missing colour but a couple of them. This is especially true when you opt to embroider on a coloured fabric as the background will greatly influence the rest of the colours. Keep the original image and the colour reference sheet with you at all times to guide your decisions.

Take your time to plan your colours

While a bit pricey, it is always a good investment to have your own commercial colour chart; most embroidery suppliers have charts of popular thread brands. It is a whole different experience to create a colour palette at home, with natural light and taking your time to delve into the thread samples rather than choosing your colours hastily in the shop. Write down the numbers of your chosen colours as well as the alternatives to them, as when you see the skeins at the store you might feel one of them doesn't look quite right and you may need to adjust it. Don't forget to bring the background fabric to visualize the overall effect.

There is a summary of how to create a colour palette through colour sensitivity on page 13.

Checklist for creating a colour palette through colour sensitivity

◯ Find your chromatic source (see page 61)

◯ Capture your colours (see pages 62 and 66).

◯ Record your significant colours on to a colour reference sheet using coloured papers, paint chips or paint your own swatches (see page 64).

◯ Arrange your samples by colour family or temperature and organize them in light-to-dark or vivid-to-muted sequences, which you can always return to later.

◯ Match your project colour swatches (A) to the closest colour on the commercial colour chart of your chosen material (B)

◯ Write down your first choice colours to create a colour chart (C). Make a note of alternatives to them in case you want or need to adjust when you are in the shop.

◯ Have your background fabric with you when you are making your final choice of colours so you can place the colours against the proposed fabric. Remembering to do this in natural light if possible.

◯ The final stage is creating your colour palette— see page 72.

B. COMMERCIAL COLOUR CHART

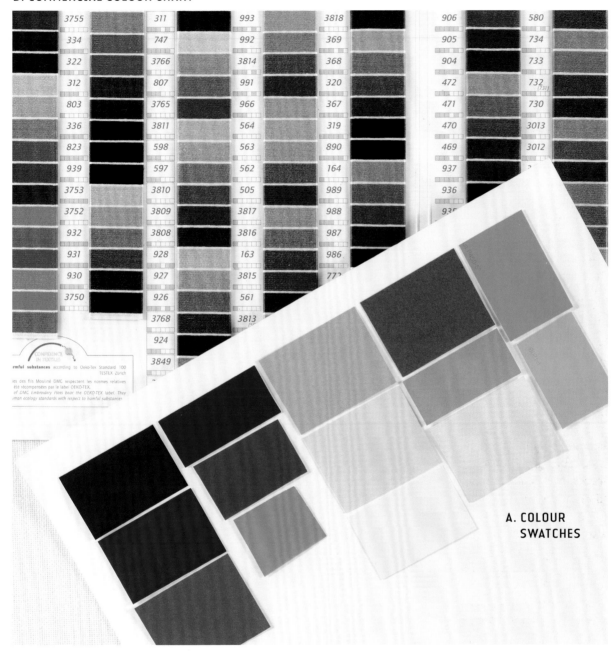

A. COLOUR SWATCHES

C. YOUR COLOUR CHART

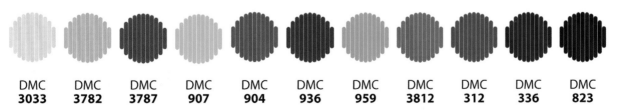

DMC 3033	DMC 3782	DMC 3787	DMC 907	DMC 904	DMC 936	DMC 959	DMC 3812	DMC 312	DMC 336	DMC 823

How to Create Your Palette

After capturing, registering and translating the colours from an object or image, this final step—similar to Choosing colour roles on page 46—will deliver your final palette masterpiece.

Different colour roles

Just as with colour roles within a palette, you will differentiate the same parts in your embroidery design: the main and supporting characters and an accent or striking detail. The main character will probably be the most essential subject in the motif; it is what the overall piece is about. Secondly, the supporting or subordinate designs contribute to the storytelling and enhance the role of the leading character. The accent may be a small figure in itself or a detail from the main or supporting designs that becomes noticeable by distinctive colour use. Remember that if you work with a coloured background, it will have an active role as well and it should be considered as another character in the play: it may add to the dominant colour or to the subordinate one according to the look and feel you wish to express with it.

The role of motifs

When you assign the colours according to their role in the palette, take into account the motif's role within the design for it will guide you to the most balanced selection of colours. This means that you have to evaluate the expanse and complexity of each part of the design and eventually revise the colour alternatives in your chart to achieve the most accurate proposal.

If a motif is quite complex—that is, composed by several parts or sections—you will need a broad range of colours to fill in each of the segments and ensure well-differentiated areas.

Consider the mood

Think about the mood you want to create and extend the range in that direction. For a muted mood, you can pick, for instance, three muted tones in a value scale (three lighter, three darker or one light, one medium and one dark) and add a fourth shade from an opposite mood (but still coherent to the general concept) to avoid a flat appearance.

Using colour for effect

If a motif is too large and covers an expanse of the background, you may want to downplay it by using subdued rather than striking hues; conversely, small figures do better if they display a noticeable colour compared to the rest of the motifs and/or base fabric otherwise there is a risk they will disappear into the background. Stitching a large dominant motif with powerful colours can result in an unbalanced piece but it depends on the final effect you want to achieve.

Create a colour plan

To judge which of the palettes will work best with your design, use a colour plan to help visualize the colours before beginning any stitching. Trace a black and white outline of your design (half or quarter of the actual size) and make a couple of photocopies. With pencils colour in all the parts of the motif, experimenting with the different colour roles proposed in the palettes, until you get a look you like. This step is crucial as it can throw up colours in your chart which may need to be broadened or even discarded.

In the following pages there are several palettes illustrating this process: from finding colours to visualizing the proposed palettes in a diagram. These are just *some* of the many possibilites that can be created out of a colour chart.

COLOUR PLAN

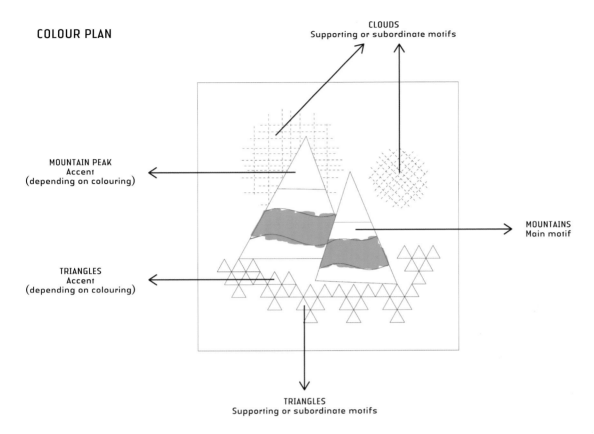

CLOUDS
Supporting or subordinate motifs

MOUNTAIN PEAK
Accent
(depending on colouring)

MOUNTAINS
Main motif

TRIANGLES
Accent
(depending on colouring)

TRIANGLES
Supporting or subordinate motifs

COLOUR PALETTES

PASSIVE BACKGROUND FABRIC

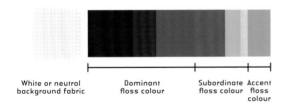

| White or neutral background fabric | Dominant floss colour | Subordinate floss colour | Accent floss colour |

ACTIVE OR COLOURED BACKGROUND FABRIC

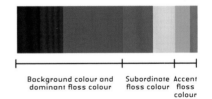

| Background colour and dominant floss colour | Subordinate floss colour | Accent floss colour |

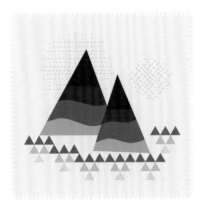

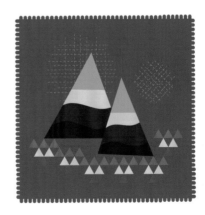

Palette 1: Things > Fabric

1. **BEIGE**
 (background)

2. **GREY**
 (linen fabric base and printed motifs)

3. **LIME GREEN**
 (printed motifs)

This step-by-step process can be used for each of the palettes on the following pages

Step 1
Capture the colours
Step 2
Register the mood of the captured colours
Step 3
Create a colour chart
Step 4
Create colour plans with varying palettes
Step 5
Choose your preferred colour palette

REGISTRATION OF CAPTURED COLOURS

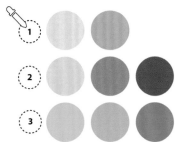

Have a look at your fabric stash for new colour inspiration! It doesn't matter if the pattern of the fabric contains just one or two different shades—you can always open up the range by looking at the highlights and shadows of each of the colours. Look how the arrangement of the fabric squares creates a three-dimensional surface of an otherwise flat material revealing lighter and darker variations of the spotted colours. This screen-printed linen has a rather cool appearance: the lime green and grey suggest a fresh and citrus feeling while the background appears as a warm neutral base producing a lovely softened contrast.

COLOUR CHART

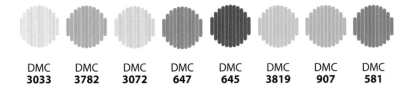

| DMC 3033 | DMC 3782 | DMC 3072 | DMC 647 | DMC 645 | DMC 3819 | DMC 907 | DMC 581 |

COLOUR PALETTES

WHITE/NEUTRAL BACKGROUND FABRIC

COLOURED BACKGROUND FABRIC

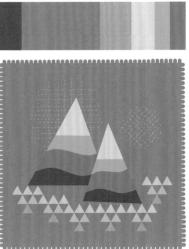

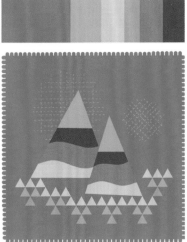

Palette 2: Things > Materials

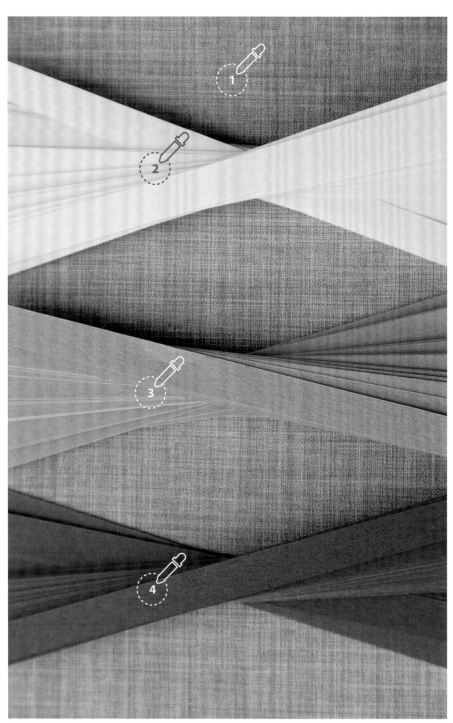

1. **GREY AND BLUE**
 (background fabric)

2. **PINK**
 (paper strips)

3. **TURQUOISE**
 (paper strips)

4. **BLUE**
 (paper strips)

REGISTRATION OF CAPTURED COLOURS

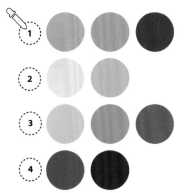

Anything can become an amazing source of colour inspiration. Even small pieces of paper! You don't need large colour samples to be able to create palettes. Just look closely and discover all the colour information inside the smallest sample, paying close attention to textures, edges and highlights of the chosen material. Notice here how the paper strips can yield several shades according to the level of light or shadow cast. And to bring more depth to the colour range, we arranged the paper strips on a textured fabric to build a richer and more suggestive background.

COLOUR CHART

| DMC 928 | DMC 3713 | DMC 760 | DMC 3811 | DMC 597 | DMC 3809 | DMC 3760 | DMC 3842 |

COLOUR PALETTES

WHITE/NEUTRAL BACKGROUND FABRIC

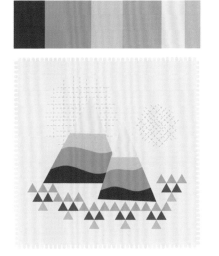

COLOURED BACKGROUND FABRIC

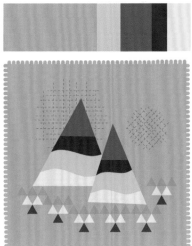

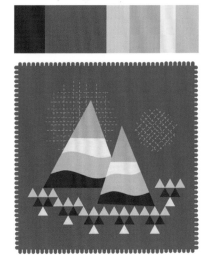

Palette 3: Things > Collections

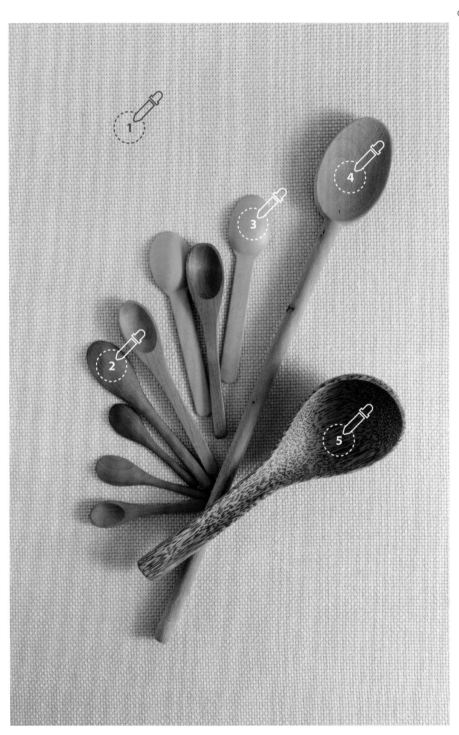

1. **WARM GREY**
 (background tablecloth

2. **BURNT ORANGE**
 (reddish wooden spoon

3. **PINK**
 (plastic spoons)

4. **BEIGE AND BROWN**
 (light wooden spoon)

5. **BROWN**
 (wooden ladle)

REGISTRATION OF CAPTURED COLOURS

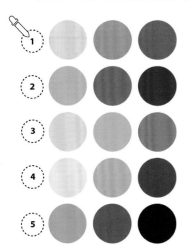

Do you like to collect something? Collections usually revolve around themes—same object category, colouring, material or appearance. Go through your treasured sets and look for common themes; arrange the elements by various criteria until you achieve a good colour chemistry between them. Display the objects against a background or in a space that relates or contributes to the spirit of the collection; in this case we have placed the spoon collection on a thick weave tablecloth to convey a handmade feeling. Here the different types of wood contribute with broad range of hues, values and saturation: from the soft beige of the long spoon to the intense orangey tones of the small ones. Note how the pink spoons play the ultimate accent role in the selection: slightly cooler in colour, made of synthetic material and definitely cheaper or less noble than the rest.

COLOUR CHART

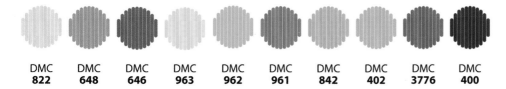

| DMC 822 | DMC 648 | DMC 646 | DMC 963 | DMC 962 | DMC 961 | DMC 842 | DMC 402 | DMC 3776 | DMC 400 |

COLOUR PALETTES

WHITE/NEUTRAL BACKGROUND FABRIC

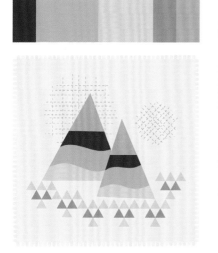

COLOURED BACKGROUND FABRIC

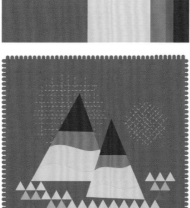

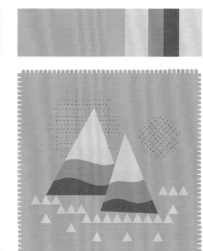

Palette 4: Scenes > Styled images

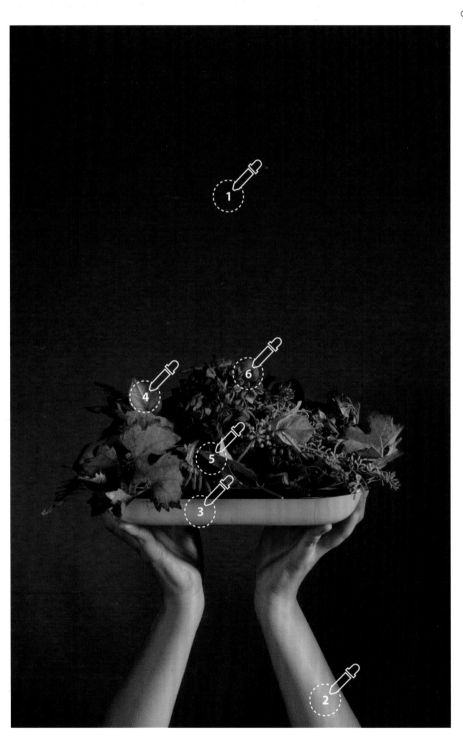

1. **DARK GREEN**
(background)

2. **SKIN TONES**
(arms and hands)

3. **GREY**
(enamel dish)

4. **FUSCHIA**
(bougainvillia flowers)

5. **GREEN**
(fresh leaves)

6. **HONEY AND BROWN**
(dried leaves)

REGISTRATION OF CAPTURED COLOURS

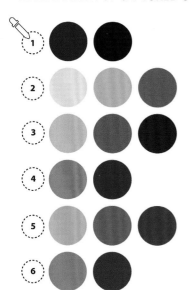

Look for colour sources in styled photographs from magazines, art and design books and websites which usually display dramatic and surprising palettes. Rather than everyday combinations these colours are usually deliberately extreme to create an impact. Capture them to translate into a project later. Here the green background goes for the leading role: it refuses to go unnoticed and with its richness of colour and deep shadows makes an active backdrop to the scene that enhances the offering gesture of the hands. Inside the enamel dish, numerous gatherings from the garden (leaves, flowers, twigs) present a wide array of colours to choose from: greens, yellow, beige, brown and a striking fuchsia.

COLOUR CHART

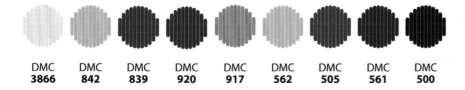

| DMC 3866 | DMC 842 | DMC 839 | DMC 920 | DMC 917 | DMC 562 | DMC 505 | DMC 561 | DMC 500 |

COLOUR PALETTES

WHITE/NEUTRAL BACKGROUND FABRIC

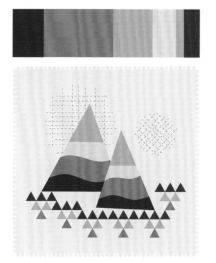

COLOURED BACKGROUND FABRIC

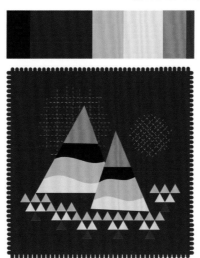
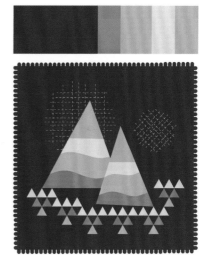

Palette 5: Scenes > Table-setting

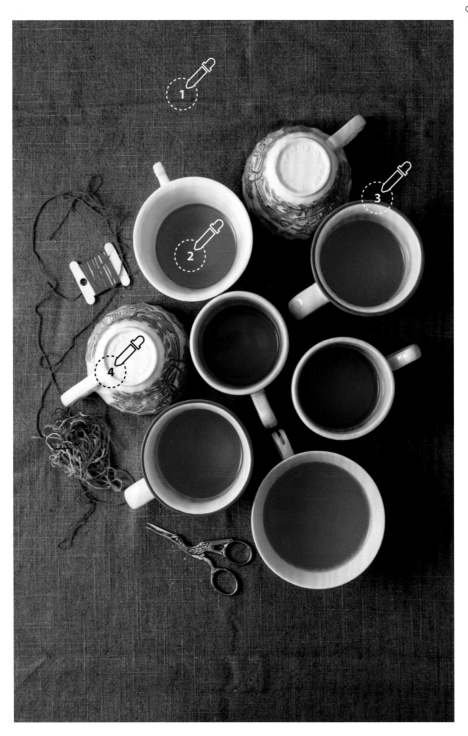

1. **MUTED BLUE**
 (linen tablecloth)

2. **RED**
 (raspberry tea)

3. **SKY BLUE**
 (cup rim)

4. **ECRU AND SOFT GRE**
 (porcelain)

REGISTRATION OF CAPTURED COLOURS

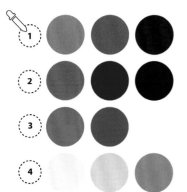

Whether it is at home, a café or restaurant, keep an eye on the art of table-setting. The stories shared around tables are full of life, laughter, delicious food and drink. Get in the habit of photographing tables when they are first laid, then with guests and later when people have left. The colours of food and drinks, the mix of flavours, the changing light, the stains on napkins and tablecloth can become inspirational concepts for new palettes. This picture puts together the cups of tea and the short lengths of floss left on a table after an embroidery class (people get so immersed in their pieces that they usually forget to drink their tea!). Red and blue are the two main colours in this scene and they appear in vivid, muted and dark shades thus building a broader colour range to work with.

COLOUR CHART

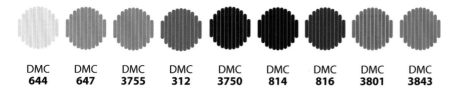

| DMC 644 | DMC 647 | DMC 3755 | DMC 312 | DMC 3750 | DMC 814 | DMC 816 | DMC 3801 | DMC 3843 |

COLOUR PALETTES

WHITE/NEUTRAL BACKGROUND FABRIC

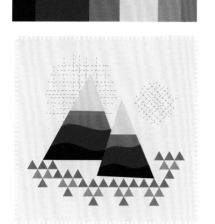

COLOURED BACKGROUND FABRIC

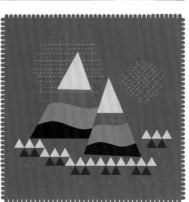

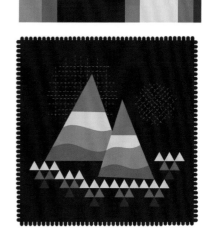

Palette 6: Scenes > Worktable

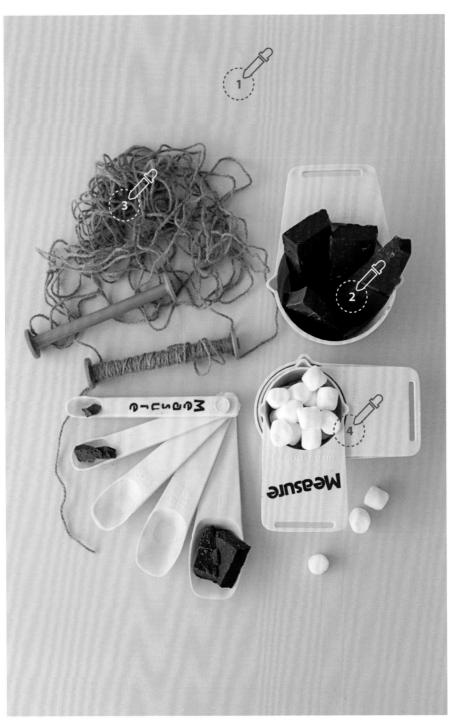

1. **PINK**
 (background)

2. **BROWN**
 (chocolate)

3. **BEIGE AND TAUPE**
 (yarn and weaving bobbin)

4. **ECRU AND CREAM**
 (marshmallows and measuring cups)

REGISTRATION OF CAPTURED COLOURS

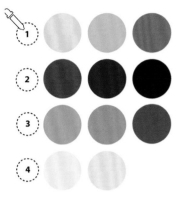

Are you a crafty person or perhaps you like to cook? If so you may have noticed that your work surface can yield an ever-changing scene of colour inspiration. Don't miss the opportunity to record the *mise en place* before cooking your specialty dish or after finishing a DIY project: raw materials (whether edible or not), scraps, crumbs and trade tools can tell the most appetizing colour stories. The unexpected mix of chocolate and alpaca yarn is connected by the temperature and saturation of their colours: they are warm and muted and collaborate in the making of a luscious and cosy atmosphere.

COLOUR CHART

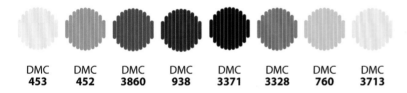

| DMC **453** | DMC **452** | DMC **3860** | DMC **938** | DMC **3371** | DMC **3328** | DMC **760** | DMC **3713** |

COLOUR PALETTES

WHITE/NEUTRAL BACKGROUND FABRIC

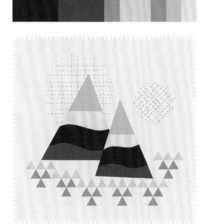

COLOURED BACKGROUND FABRIC

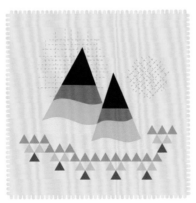

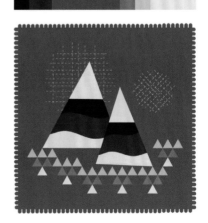

Palette 7: Scenes > Home

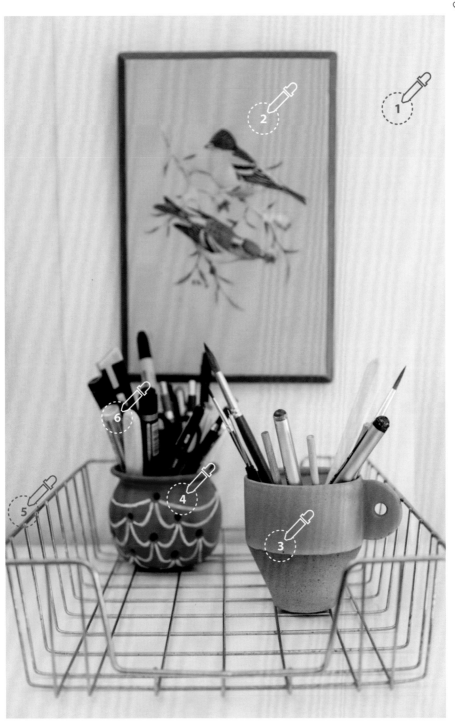

1. **SOFT GREY**
 (wall and table)

2. **YELLOW**
 (bird picture)

3. **LIGHT TEAL AND CARAMEL**
 (ceramic pencil holder)

4. **TERRACOTTA**
 (red clay pencil holder)

5. **BEIGE AND OLD GOLD**
 (golden wire rack)

6. **AQUAMARINE AND BLUE**
 (details in pens)

REGISTRATION OF CAPTURED COLOURS

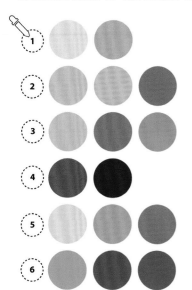

Any area of your house can serve as inspiration when looking for colours combinations. Is there a special corner in your bedroom or studio that makes you feel good every time you look at it? Probably that spot, however small it may be, has some gorgeous colours that make your eyes sing. The yellow in the picture runs through the whole corner with warm undertones: notice how the colours in the clay and ceramic pencil holders and golden wire rack connect with the leading yellow while the presence of light teal and aquamarine brings a refreshing tone to the composition. Notice the presence of the soft grey in the wall and table and how it infuses a calming mood to the scene.

COLOUR CHART

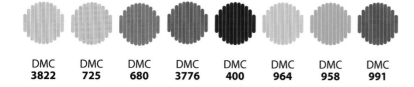

| DMC 3822 | DMC 725 | DMC 680 | DMC 3776 | DMC 400 | DMC 964 | DMC 958 | DMC 991 |

COLOUR PALETTES

WHITE/NEUTRAL BACKGROUND FABRIC

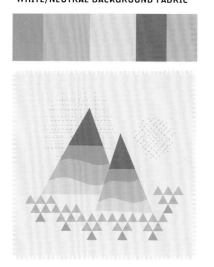

COLOURED BACKGROUND FABRIC

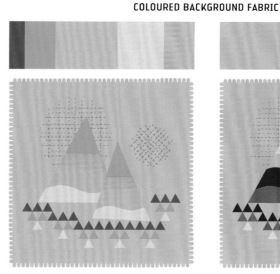

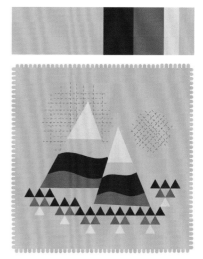

Palette 8: Places > Neighbourhood

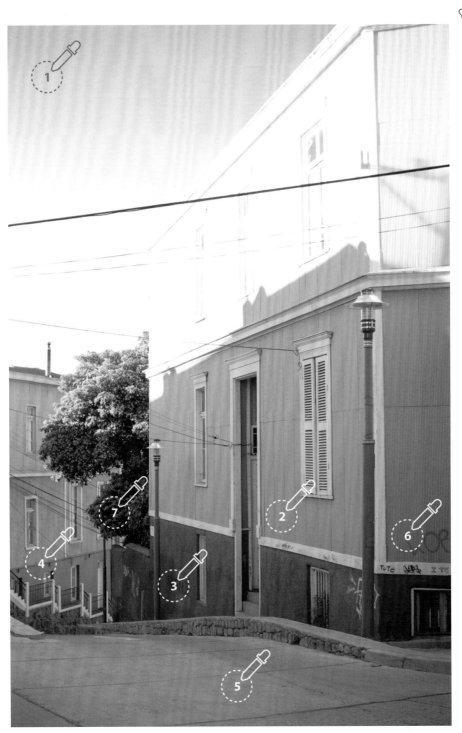

1. **BABY BLUE**
 (sky)

2. **LILAC**
 (foreground house)

3. **TAUPE AND BROWN**
 (base of foreground ho...)

4. **LIGHT BLUE**
 (background house)

5. **LIGHT TAUPE**
 (pavement)

6. **SKY BLUE**
 (graffiti detail on
 foreground house)

7. **GREEN**
 (tree foliage)

REGISTRATION OF CAPTURED COLOURS

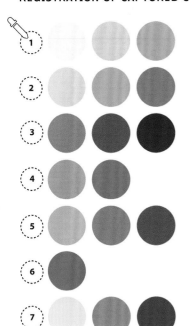

Next time you go out for a walk, take your camera and be ready to shoot. Some neighbourhoods have distinct colours on their houses (because of paint colour or building materials) and can make for great inspiration. Visit the same place during different seasons and at various times of the day and you will be surprised to discover how colours change according to the specific light of the moment. The houses in the hills of port city of Valparaiso in Chile are renowned for their colourful facades. This corner painted in pastel colours blends smoothly with the muted tones from the pavement and sidewalk. And don't ignore the graffiti or other urban details on the walls—they can bring unexpected colours to your palette.

COLOUR CHART

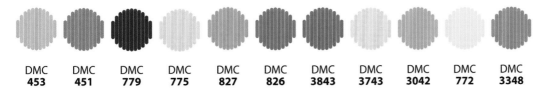

| DMC 453 | DMC 451 | DMC 779 | DMC 775 | DMC 827 | DMC 826 | DMC 3843 | DMC 3743 | DMC 3042 | DMC 772 | DMC 3348 |

COLOUR PALETTES

WHITE/NEUTRAL BACKGROUND FABRIC

COLOURED BACKGROUND FABRIC

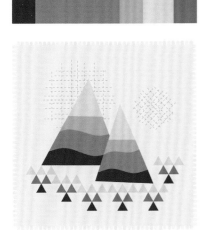

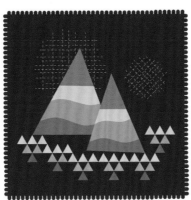

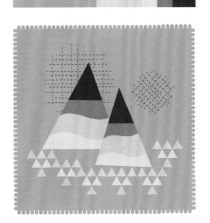

Palette 9: Places > Places of interest

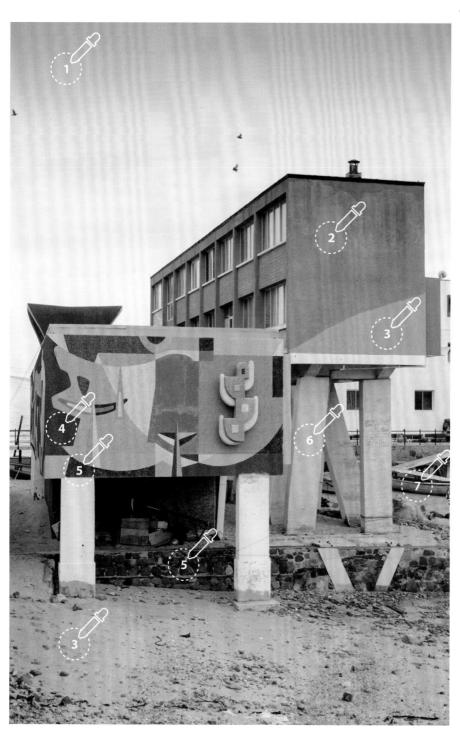

1. ECRU, LIGHT TAUPE A▮ LIGHT GREY (sky)

2. GREENISH GREY (building walls)

3. SAND AND BROWN (sand and mosaic wall)

4. SANGRIA AND BURGUNDY (mosaic w▮

5. GREY AND GRAPHITE (bottom stone wall and mosaic wall)

6. SOFT GREY (building pillars)

7. ORANGE AND YELLOW (details from fishing bo▮

REGISTRATION OF CAPTURED COLOURS

Can't find inspiring spots near your area? Then plan colour scouting visits to places that are known for their beauty and colouring. What do tourists do in your city or region? Chances are there are amazing places brimming with colour ideas that you can visit again with new freshly trained eyes. This building is located on the Chilean coast and houses the Institute of Marine Biology. Besides its distinctive architecture, it displays a striking pebble mosaic on the walls that makes for a sophisticated muted palette created from a very simple formula (complementaries red and green blended with neutrals). The proximity to the sea, with its changing weather conditions from bright sun to dense fog, transforms minute by minute the intensity of the colours offering new alternatives from the same place.

COLOUR CHART

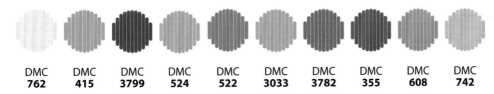

| DMC 762 | DMC 415 | DMC 3799 | DMC 524 | DMC 522 | DMC 3033 | DMC 3782 | DMC 355 | DMC 608 | DMC 742 |

COLOUR PALETTES

WHITE/NEUTRAL BACKGROUND FABRIC

COLOURED BACKGROUND FABRIC

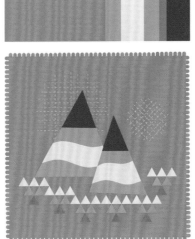

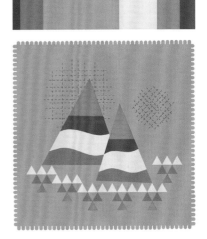

Stitching with Colour

In the following pages there are five different projects which show how a colour palette is created and stitched. The first three are built from colour theory while the remaining two draw colour inspiration from palettes created in the previous chapter. Each project describes how the used stitch relates to the design or to the properties of the medium and how the colour palette connects to the expected appearance of the piece. If you are a beginner embroiderer, we recommend that you read the stitch instructions from all five projects so you have a stronger grasp of the techniques involved.

Once you feel confident with your colour skills, don't hesitate to try any of these projects with a palette of your own that makes sense to the specific colour story you want to tell. Good luck!

Project: **Sleeping mask**

TECHNIQUE
Trellis square (vertical and horizontal laid stitch *see* page 96; cross-stitch *see* page 118)

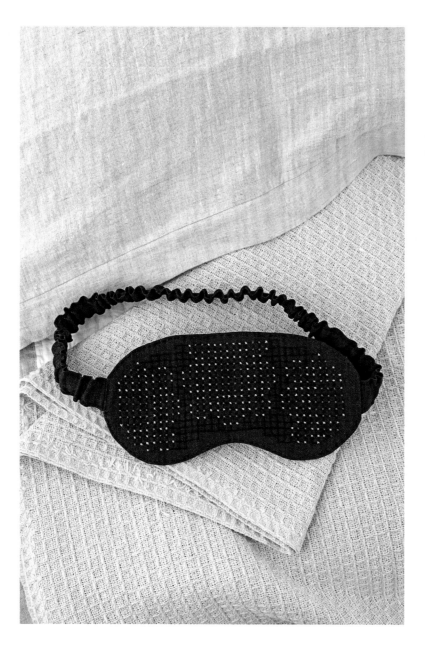

Dreams can't get any more relaxing with this delicate embroidered eye mask. Inspired by crocheted motifs, the flowery garland is stitched using the trellis square filling which creates a subtle pattern when done with fewer strands. The trellis filling consists of a square grid—made up of two overlapped layers of vertical and horizontal laid stitches—that is couched by small cross-stitches which resemble a beaded effect.

COLOUR SCHEME
Monochromatic
(silver, blue)

COLOUR CHART

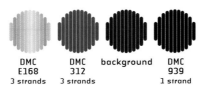

DMC E168 3 strands | DMC 312 3 strands | background | DMC 939 1 strand

COLOUR PALETTE

About the palette

The calming power of blue and a quiet monochromatic palette (see page 33) are just what is needed for a good night's sleep. The colours resemble a clear starry night: dark blue background with stitches in very dark navy blue and dark baby blue. The accent colour is created by the silver metallic thread that highlights the motif in a jewel-like fashion. If you try another palette, be sure to look for colour clues in your chosen background as it may suggest an obvious monochromatic scheme proposal for your embroidery.

Materials

- Medium weight fabric (preferably cotton or linen)
- 6-strand cotton embroidery floss
- Embroidery needle (sharp point)
- Embroidery hoop (at least 20cm/8in diameter)
- Scissors (embroidery)
- Thin awl (or sharp point)
- Sewing thread (a colour that is not part of the palette)
- Water-based ink 1.0 pen
- Copier paper for template on page 122
- Batting or wadding to fit template
- 40cm (15¾in) elastic 1.5cm (⅗in) width)

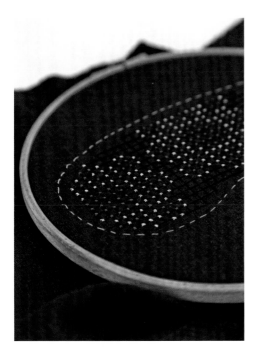

Stitches

TRELLIS SQUARE FILLING

Stage 1 – Vertical and horizontal laid stitches

① Knot the thread. Insert needle at a point that is at least 8cm (3in) away from the starting point a. Following the marked dots, come up in a and go down in b. Come up again in the dot next to b and go down in the dot above it (the aim is to join the top and bottom dots with vertical lines). Continue until the bottom layer of vertical stitches is completed.

② This stitch turns out best if you start the first laid stitches from the longest side and carry on towards the shorter side. Thus, by starting with the longest stitch, you can set the correct direction and angle of the stitches.

③ Once the first layer of vertical stitches is completed, start the horizontal layer of laid stitches by coming up in a and going down in b on the opposite side. Work in the same way as the vertical layer. The horizontal layer sits on top of the vertical one without any interweaving; they just overlap at this stage.

④ To cast off a thread, work on the wrong side and slide the threaded needle under four or five stitches. Cut off the thread.

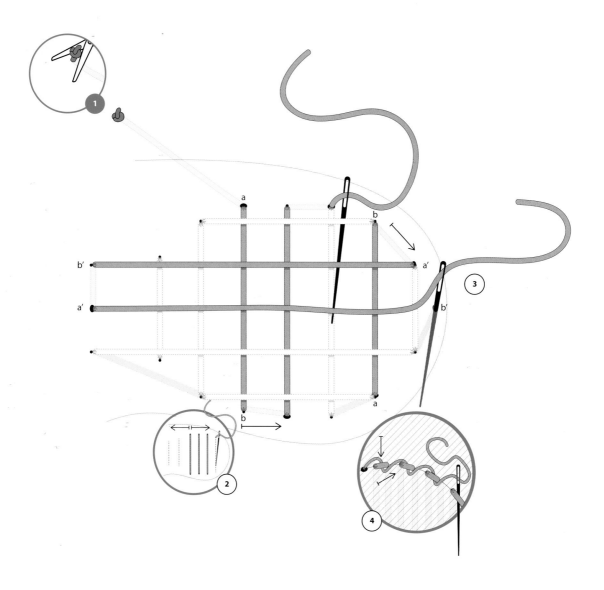

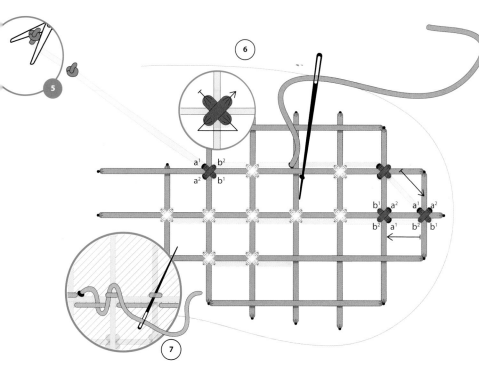

Stage 2
– Couching cross-stitches

⑤ Knot thread for the couched cross-stitches. Insert needle at a point at least 8cm (3in) away from the starting point.

⑥ Come up at *a*, very close to the intersection point of the underlying vertical and horizontal stitches. Make a small cross-stitch to couch each crossing. Continue following the colour changes in the diagram below until the row is complete.

⑦ To cast off a thread, work on the wrong side and slip the threaded needed until four or five stitches. Cut thread.

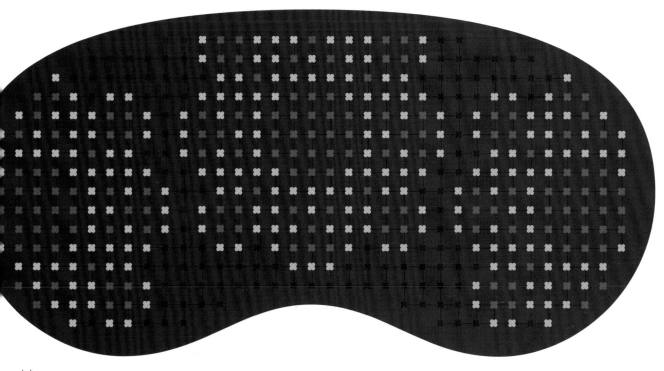

Vertical and horizontal laid stitches

∷ Couching cross-stitches

Mount fabric in hoop: place inner ring on a table, lay fabric over it and nest the outer ring over the fabric and inner ring, pushing softly until it fits (loosen knob for an easy fit). Tighten ring. Use a hoop that is at least 20cm (8in) diameter so the hoop can remain in position until you finish.

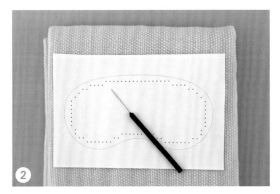

Photocopy or trace the mask template (page 122) on copier paper. Place the paper over a cushioned surface (a folded towel works well) and with an awl prick all the dots marked on the template. Cut out template following the outer seam line.

Pin template on mounted fabric aligning with the grain of the fabric (in either direction). Cut a length of sewing thread (choose a colour outside the palette being used) and make a running stitch following outer shape of pattern. Keep the stitches short to create the curves of the shape.

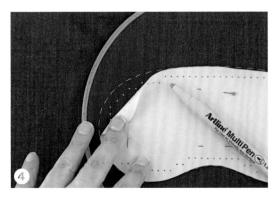

Use the water-based ink pen to mark all the pricked holes on to the fabric. Check fabric regularly to make sure the dots are noticeable enough and mark again if necessary. Keep dots small and consistent.

Cut about 45cm (17¾in) of embroidery floss, thread needle and knot. Follow directions for trellis square filling as shown on page 96: stage 1 (two layers of overlapped vertical and horizontal laid stitches) and stage 2 (couching cross-stitches), changing colours as necessary.

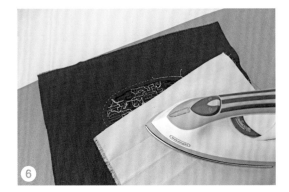

Once finished, remove embroidery from the hoop and lightly steam iron on the wrong side using a piece of calico or tea towel in-between. Do not press, just apply steam and glide gently. If the chosen fabric is very light use a fusible web to strengthen i Add a 1cm (½in) seam allowance, fold over to wrong side and carefully stitch along seam line.

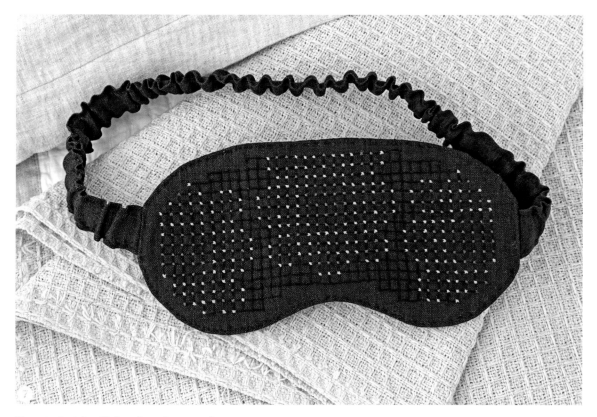

How to finish off the sleeping mask

- Cut the following pieces:
 (1) back piece cut to bias in main fabric using mask
 template on page 122. Add 1cm (⅜in) allowance
 (outside template seam line).
 (1) thin batting piece using mask template. Add 1cm
 (⅜in) allowance (outside template seam line).
 (1) strap 6 x 60cm (2¼ x 23½in) cut to grain in main
 fabric (seam allowance included).
- Fold strap lengthwise with right sides facing. Sew
 7mm (¼in) from long edge. Turn strap right side
 leaving seam in the centre of one of the sides. Press.
 Stitch both sides at 2mm (¹/₁₆in) from edge. Insert
 1.5cm- (⅝in-) wide elastic (40cm (15¾in) long)
 anchoring with a couple of stitches at both ends.

- Lay three mask pieces together: face the
 embroidered side with right side of back piece,
 place batting piece behind back piece. Pin. Put
 elastic strap between fabric pieces aligning its
 centre with the marks in the template. Sew all
 pieces together leaving a small opening. Trim
 excess seam allowance, turn the mask right side
 out, reshape and press. Hand stitch the opening to
 close. Stitch a small running stitch along the mask
 border to achieve a light padded effect.
 Sweet dreams!

Project: **Embellished knitted sleeves**

TECHNIQUE
Duplicate stitch *see* page 102

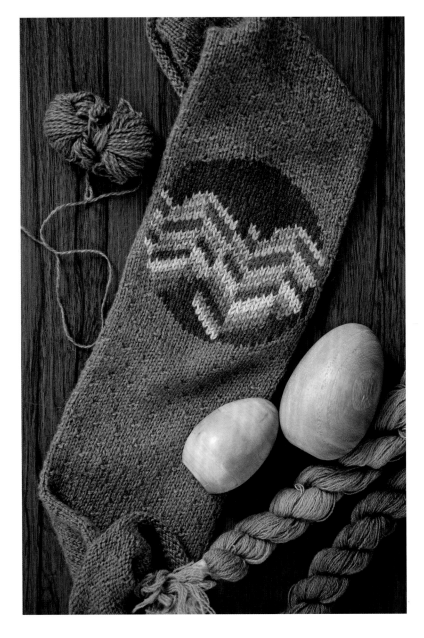

Revamp your knits! Duplicate stitch or swiss darning is an excellent way to embellish your knits as well as reinforce any areas that are growing thinner with wear (like elbows in jumpers and heels in socks). You can work on any knit as long as it is in stocking/ stockinette stitch. Once you grasp the technique, you will be embroidering all your jumpers!

COLOUR SCHEME
Analogous (see page 33)
(blue-violet, blue)

COLOUR CHART

| Appleton 564 | Appleton 565 | Appleton 562 | Appleton 561 | Appleton 743 | Appleton 746 | Appleton 105 | Appleton 104 | Appleton 103 | Appleton 101 | Appleton 885 |

About the palette

Because this is a project that can be done with any knit, consider using the base colour as the starting point for creating the palette. These sleeves were knitted in a greenish-grey wool reminiscent of sage or lavender leaves. Therefore we chose violet as the main colour for the embroidery. As the motif is inspired by Missoni knits, the palette builds from an analogous colour scheme (see page 33), which creates a unified and balanced combination with violet, blue-violet and blue.

Materials

- Knitted garment (area to be embellished should be in stocking/stockinette stitch)
- Crewel, tapestry or mending/darning wool*
- Tapestry needle (blunt point)
- Scissors (embroidery)
- Darning egg
- Piece of cardboard
- Cotton perlé thread
- copier paper

*The wool used should match the thickness of the knitted garment. Appleton wool comes in crewel weight (2 ply) or tapestry weight (4 ply).

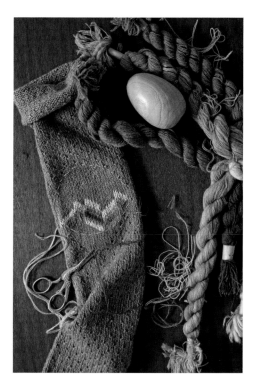

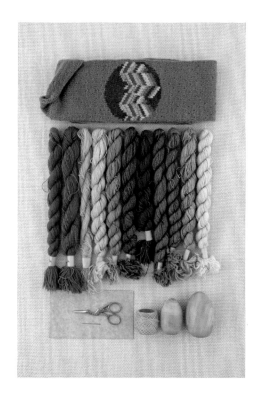

Stitches

DUPLICATE STITCH

① Knot thread. Insert needle at a point that is at least 8cm (3in) away from starting point a. Come up at a; point a will always be the bottom point of each 'V' stitch. This stitch is easier if you always see the stocking/stockinette stitches as a 'V'. Slide the threaded needle from right to left under points b and c as marked.

② To complete the stitch, insert the needle again at point a and come up at the bottom point (a) of the next 'V' along.

Once again, slide the threaded needle from right to left under points b and c. Continue in this way until the row or colour section is complete.

③ To make a return row, work from left to right in the same way.

④ To cast off, working on the wrong side, weave the threaded needle under four or five stitches. Cut thread.

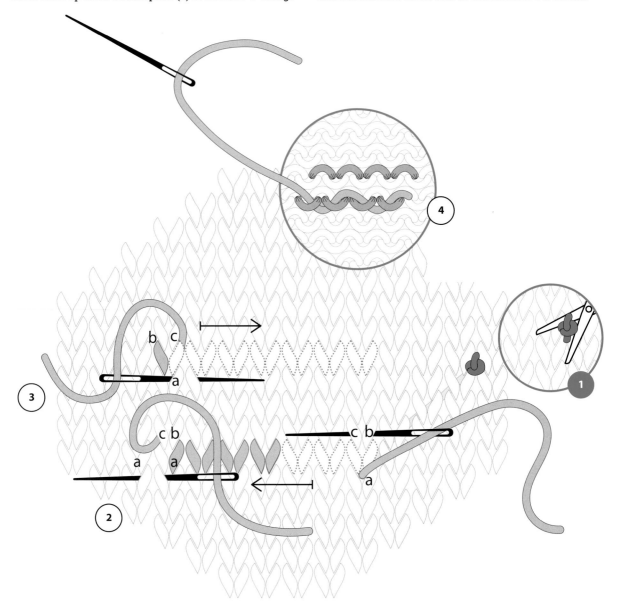

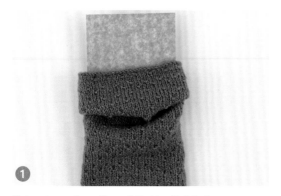

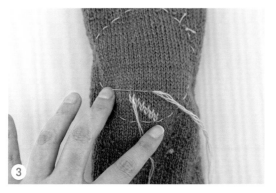

Cut a piece of cardboard that is slightly larger than the embroidery motif (or worn area that is being patched). Place underneath the section to be embellished (this will help prevent stitches being picked up in error from the bottom layer, especially when working in confined areas like sleeves).

Cut a circle template to the desired size in copier paper; here 9 cm (3½ in) diameter. Pin over the area to be worked. Using a length of cotton perlé thread of contrasting colour, make a running stitch around the edge of the template. Remove template from the garment and set aside.

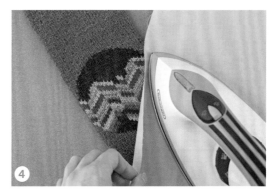

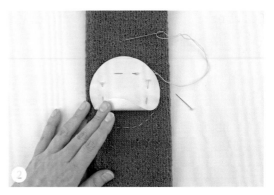

Cut approximately 45 cm (17¾ in) of chosen wool (2 ply is used here) thread needle and knot one end. Use a darning egg to make the duplicate stitch (see opposite page) easier. Follow the colour guide on page 123. The stitch can be worked in rows, columns and diagonals. Remember not to pull the thread too tight; allow each new stitch to sit on the surface of the knit with a similar tension.

Once finished, wash the piece to allow the embroidered stitches to settle. Steam iron gently on the wrong side, with a piece of calico or tea towel in-between. Do not press, just apply steam and gently smooth.

Project: **Tea towel with woven patches**

TECHNIQUE
Weave stitch *see* page 106

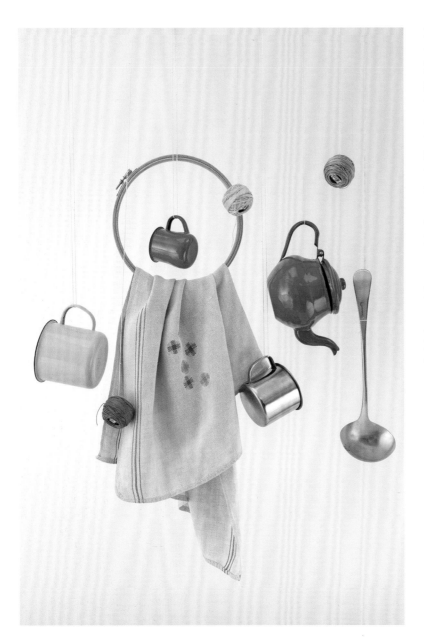

Do you have a cherished vintage tea towel that has seen better days? It doesn't matter if it is torn or stained, these woven patches can conceal any small imperfection on the fabric. The weave stitch resembles the plain weave of the tea towel and if you use a floss that is similar to the yarn of the fabric, the embroidery will become part of the background. Work with circles (or other simple shape) and scatter to cover any spots and holes – or just for decoration.

About the palette

Decades of continuous use and washes will have left threads and prints of a vintage tea towel somewhat faded, with softened colours. In order to maintain and respect that spirit, choose a muted palette so the stitches look as if they have always been there. And to jazz things up a bit, a complementary colour scheme (see page 34) will add a subtle colour clash to any existing colour (in this case, the red of the side stripes).

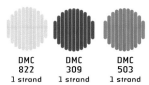

DMC
822
1 strand

DMC
309
1 strand

DMC
503
1 strand

Materials

- Linen tea-towel (or any other woven piece that needs to be mended)
- Cotton perlé thread (n°8)
- Tapestry needle (blunt point)
- Embroidery needle (sharp point)
- Scissors (embroidery and paper)
- Embroidery hoop
- Piece of cardboard
- Double-sided tape
- Circle template (or glass or cup to draw around)
- Sewing thread in contrasting colour

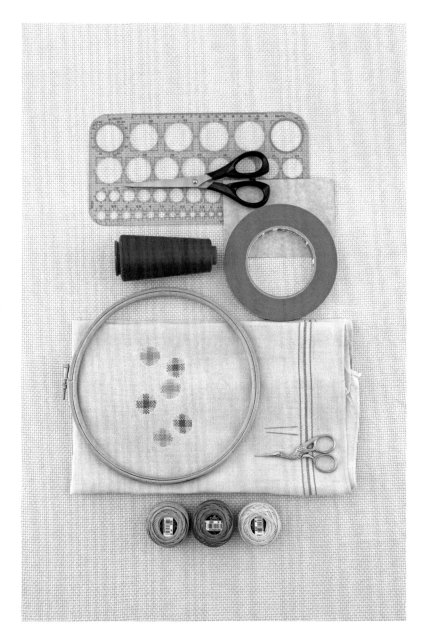

Stitches

WEAVE STITCH

① Knot thread. Insert needle at a point that is at least 8cm (3in) away from starting point *a*. Come up in *a* and go down in *b*. Come up again in *a* (close to first *b*) and go down in the *b* above it (close to first *a*). Carry on toward the side of the circle. Once finished, work on the other side.

 Cut off knot and thread needle with the thread tail. On the wrong side slide the threaded needle under four or five stitches. Cut off thread.

② When making laid stitches on a tapered or irregular-shaped portion, always make the first stitch in the longer part of it (being the centre or side of the motif). Thus, you will keep the desired inclination of the stitch.

③ To cast off a thread, work on the wrong side and slide the threaded needle under four or five stitches. Cut off the thread.

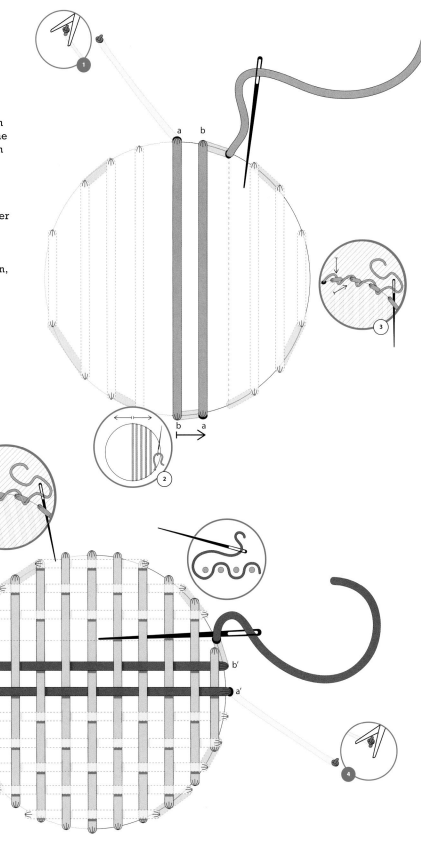

Inspect your tea towel (or other vintage textile) for stains, rips and holes. These will suggest the most appropriate shape and size for the woven patches.

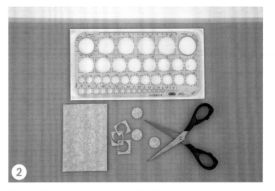

Using the imperfections or holes as a guide, roughly work out the appropriate size for the 'patches'. On cardboard, trace around an upturned glass or cup, or use a template, to create a circle that will cover any of the target imperfections. This project uses 2cm (¾in) diameter circles. Cut out.

Cut small pieces of double-sided tape and stick to one side of each of the cardboard circles.

Place the circles over the spots/holes. To visualize the effect, distribute circles over the entire surface (even where there are no stains/holes). Once layout is decided, remove protective layer on tape and stick to the background fabric (check that cardboard circles will not get in the way when mounting the hoop).

With contrasting thread, sew a running stitch around each of the cardboard templates. Remove templates and start the weave stitch as shown in the illustration (opposite) and follow guide on page 124. Use a tapestry needle to avoid splitting the threads when weaving between them.

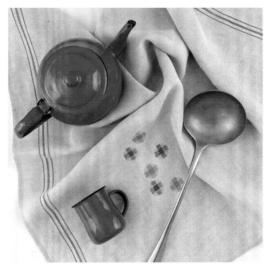

Project: **Framed embroidery**

TECHNIQUE
Chain stitch *see* page 112
Satin stitch *see* page 113

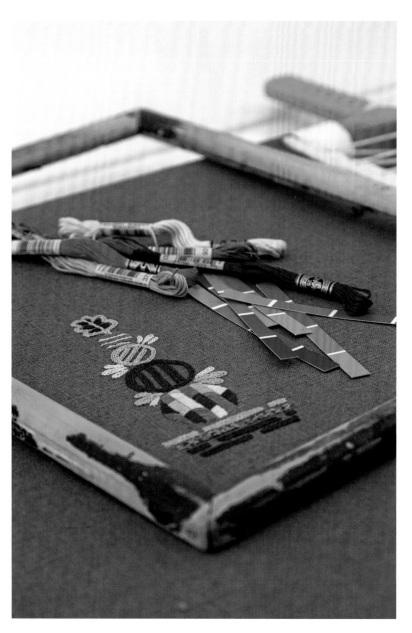

Show off your embroidery skills with this cheerful design. It combines two stitches to achieve a contrasting effect: satin stitch calls for a soft and silky look while the chain stitch creates a textured and ridged surface. The combination not only enhances the richness of texture but also plays with the colours: satin stitches slanted in opposite directions reflect the light differently and the loops of chain stitch create an interplay between light and shadow.

About the palette

This palette is built from the one extracted from the image on page 82 (Palette 5) and includes less colours as the design—bold and simple in its shape— does not require the full selection. Notice how one portion of the bottom basket is worked with strands of different colours simultaneously in the same needle (one strand of DMC 3752 and another of DMC 3750) for creating a new and richer variegated colour.

COLOUR CHART

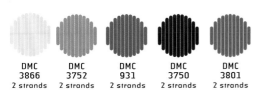

DMC
3866
2 strands

DMC
3752
2 strands

DMC
931
2 strands

DMC
3750
2 strands

DMC
3801
2 strands

COLOUR PALETTE

Materials

- Linen or medium-weight cotton
- 6-strand cotton embroidery floss
- Embroidery needle (sharp point)
- Embroidery hoop (or slate frame)
- Scissors (embroidery)
- Tissue paper
- 0.5 mm mechanical pencil (H lead)
- Sewing thread (contrasting colour to fabric)
- Pointed tweezers
- Motif template on page 125

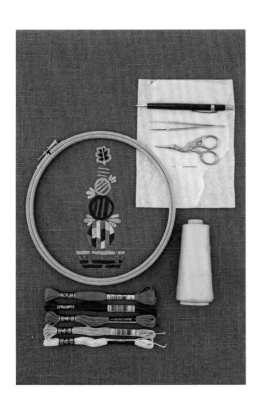

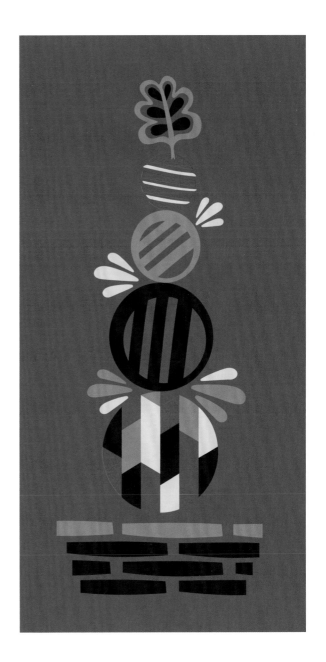

Stitches

CHAIN STITCH

To be worked in all motifs except main colour circle.

① Knot thread. Insert needle at a point that is at least 8cm (3in) away from starting point *a*. Come in at *a*. Go down in same point *a* and stop pulling the thread before the last loop goes taut. Hold the loop with your finger. Come up at point *b* and pull the thread through the loop. This completes the first chain loop.

 Cut the knot and thread the needle with the thread tail. On the wrong side slide the threaded needle under four or five stitches. Cut off the thread.

② To make subsequent stitches, insert the needle at the same point where the thread comes up from the previous chain link. Pull the thread down, hold the loop and come up in the next point *b*, pulling the thread through the loop. Keep the distance between *a* and *b* regular; it can be lengthened or shortened to fit the area you are filling in.

③ Chain stitch can be worked in rows in the same direction (always starting from the same side) or in opposite directions (turning the hoop 180 degrees). Keep the rows close to each other to achieve full background coverage.

 You can trace guide lines to help keep rows straight and/or with desired inclination and shape.

SATIN STITCH

To be worked *only* in main colour circle.

① Knot thread. Insert needle at a point that is roughly 6mm (¼ in) away from starting point and that is inside an area that will be fully covered by stitches. Work three back stitches towards point *a*. Come up at point *a* and go down at point *b* to make a slanted stitch. Come up in *a* (very close to the first point *a*) and go down in *b* (next to first point *b*). Carry on, keeping all the stitches slanting in at the same angle.

 Once you reach close to the knot, cut it off and thread the needle with the thread tail on the wrong side. Slide the threaded needle under several stitches. Cut off the thread.

② When making satin stitch on a tapered or irregular-shaped portion, always make the first stitch in the longest part of it (usually the centre or side of the motif). Thereby keeping the desired angle of the stitch consistent.

③ To cast off a thread, work on the wrong side and slide the threaded needle under several stitches. Cut off the thread.

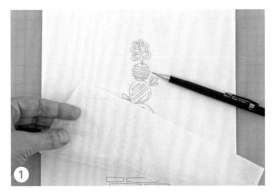

Trace motif on page 125 on to tissue paper using a mechanical pencil (H lead). This method for transferring is recommended when using a base that's too dark, textured or with an open weave which make pencil tracing more difficult.

Mount the fabric on the embroidery hoop or slate frame (show above). Centre tissue paper in the hoop or frame and pin to the fabric. Make a border of basting stitches with contrasting sewi thread to hold the paper in place. Work every line of the motif the tissue paper with short running stitches.

Carefully tear and remove all the tissue paper. Use a pair of pointed tweezers to help remove every scrap of tissue without pulling the running stitches. You can always use a water-based pigment ink pen to strengthen any line that does not appear sufficiently defined with stitches alone.

Before starting to stitch, check proposed colour palette against the background fabric. Use a commercial colour chart to ensure fabric and floss match harmoniously (or use colours on page 111). Follow stitch guide on page 125 and directions on pages 112–113. Keep stitches inside or outside the running stitch for easy removal later.

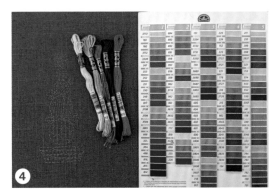

With sharp embroidery scissors and pointed tweezers, carefully cut and remove all the running stitches from the finished piece.

To frame the embroidery we used a 13 x 23cms (5 x 9in) oval wood hoop. However, choose any size or material you wish. Centre the inner ring over the motif and trace the shape using a small running stitch. Trace a line 4cm (1½in) from the stitched line and cut out embroidery.

⑦ Cut a length of double sewing thread that's slightly longer than the perimeter of the hoop shape (cotton perlé or thin twine works better if using a thicker fabric). Hem the border 1cm (½in) inside and make a running stitch all around the shape. Do not cast off the thread.

⑧ Mount the embroidery in the hoop aligning the centre running stitch with the ring of the hoop. Close and tighten knob. Remove the running stitch. On the back pull both ends of the hem running stitch until it gathers neatly inwards. Tie firmly.

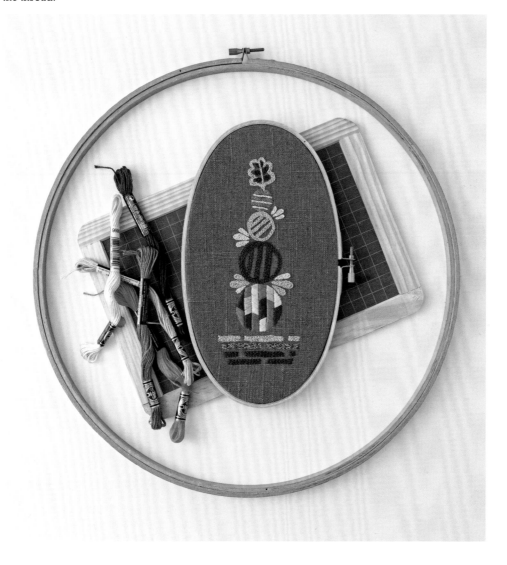

Project: **Cross-stitch tea party**

TECHNIQUE
Back stitch *see* page 117
Cross-stitch *see* page 118

Get ready for a fun tea party! Use cereal boxes to cross-stitch these fun characters that will cheer up your table. When cross-stitch is done large scale, it has a graphic, bold look that allows the background to be visible through the stitches. The cross-stitch can be worked as full or half crosses giving a solid or more veiled colour. The backstitch helps to outline certain details with a sharp line.

About the palette

This project uses the palette from page 84 (Palette 6) to infuse a warm and sweet mood into this project. These designs call for rich and delectable colours that enhance the tea party theme (a cooler palette probably wouldn't have the same appetizing effect). The cardstock background plays an important role, not only for its expanse, but for boosting the warm mood of the pieces.

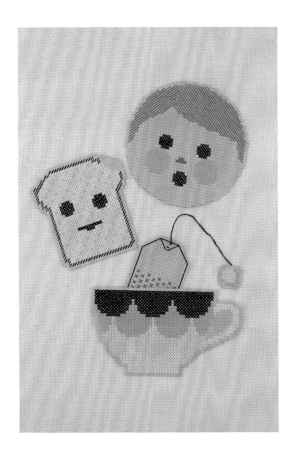

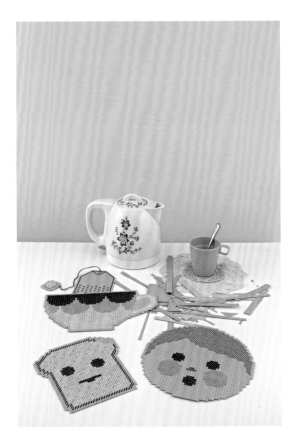

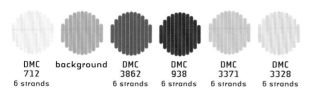

| DMC 712 6 strands | background | DMC 3862 6 strands | DMC 938 6 strands | DMC 3371 6 strands | DMC 3328 6 strands |

COLOUR PALETTE

Materials

- Cereal boxes or similar cardstock
- 6-strand cotton embroidery floss
- Cross-stitch needle (blunt point)
- Scissors (embroidery and paper)
- Thin awl (or sharp point)
- Craft knife and cutting mat
- Metallic ruler (different lengths)
- 0.5 mm mechanical pencil (H lead)
- Templates on pages 126–7

Stitches

BACK STITCH

Knot thread and insert needle at roughly five holes away from $a1$ (the knot stays on the surface). Come up in a^1 and go down in b^1 forming the first straight stitch. Come up in a^2 and go down in b^1; come up in a^3 and go down in a^2. Catch the knot thread on the back with your stitches. After four stitches, cut off the knot pulling it up so you don't cut any completed stitches. Continue, coming up with the needle one space beyond and going down in the hole of the previous stitch.

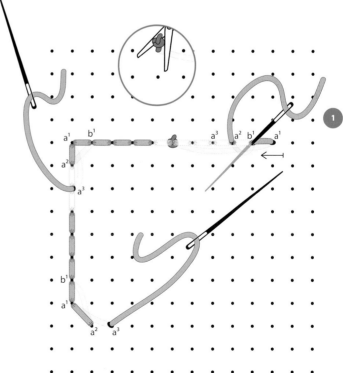

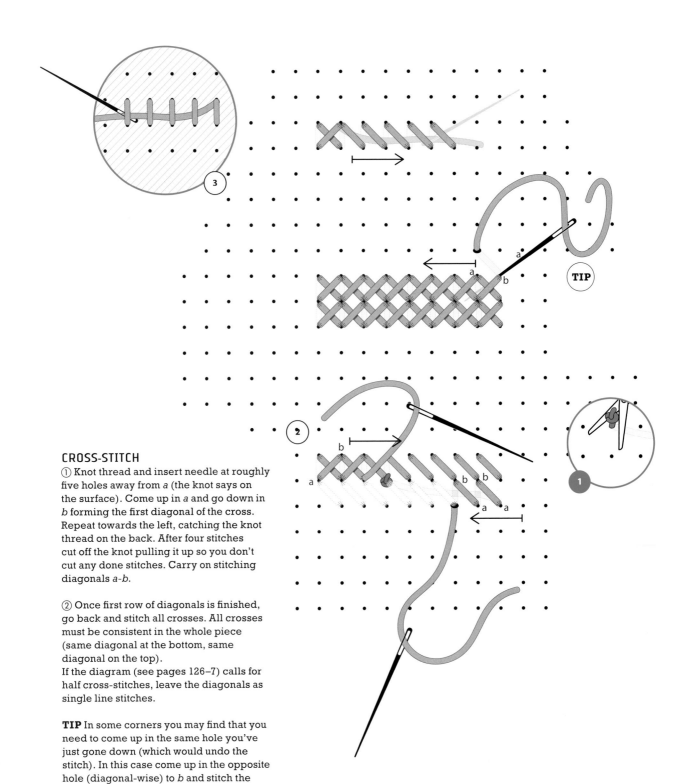

CROSS-STITCH

① Knot thread and insert needle at roughly five holes away from *a* (the knot says on the surface). Come up in *a* and go down in *b* forming the first diagonal of the cross. Repeat towards the left, catching the knot thread on the back. After four stitches cut off the knot pulling it up so you don't cut any done stitches. Carry on stitching diagonals *a-b*.

② Once first row of diagonals is finished, go back and stitch all crosses. All crosses must be consistent in the whole piece (same diagonal at the bottom, same diagonal on the top).
If the diagram (see pages 126–7) calls for half cross-stitches, leave the diagonals as single line stitches.

TIP In some corners you may find that you need to come up in the same hole you've just gone down (which would undo the stitch). In this case come up in the opposite hole (diagonal-wise) to *b* and stitch the diagonal accordingly.

③ For finishing off a thread, slide the needle on the wrong side under four or five stitches. Cut off the thread.

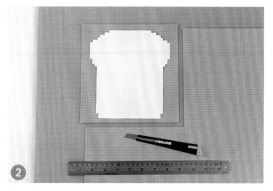

Trace a 5mm (¾in) grid on the cardstock using a 0.5mm H lead mechanical pencil. Harder leads (H) are preferable to softer (B leads) to avoid smudging the work. You can adapt the grid measurements according to the final size you want your pieces.

Having traced a surface large enough to cut out all pieces, cut sections of the cardstock large enough to hold each of the characters (add at least 1cm (½in) seam allowance). Don't worry about shapes. You will cut out precise borders once the piece is embroidered.

Perforate the cardstock using a thin awl. Place the cardstock over a cushioned surface (a folded towel works well) and prick each grid intersection until the whole area is covered. Keep holes uniform and consistent in diameter.

Cut about 45cm (17¾in) of embroidery floss, thread needle and knot. Follow directions for cross-stitch (full or half-cross) and backstitch on pages 117–118. Cover the cardstock pieces following the colours and stitches in the templates on pages 126–7.

Once you have finished embroidering, cut the edges of each of the shapes following the black cutting line shown on the templates on pages 126–7.

Join the tea bag to the label using a length of embroidery floss (roughly 20cm (7¾in)).

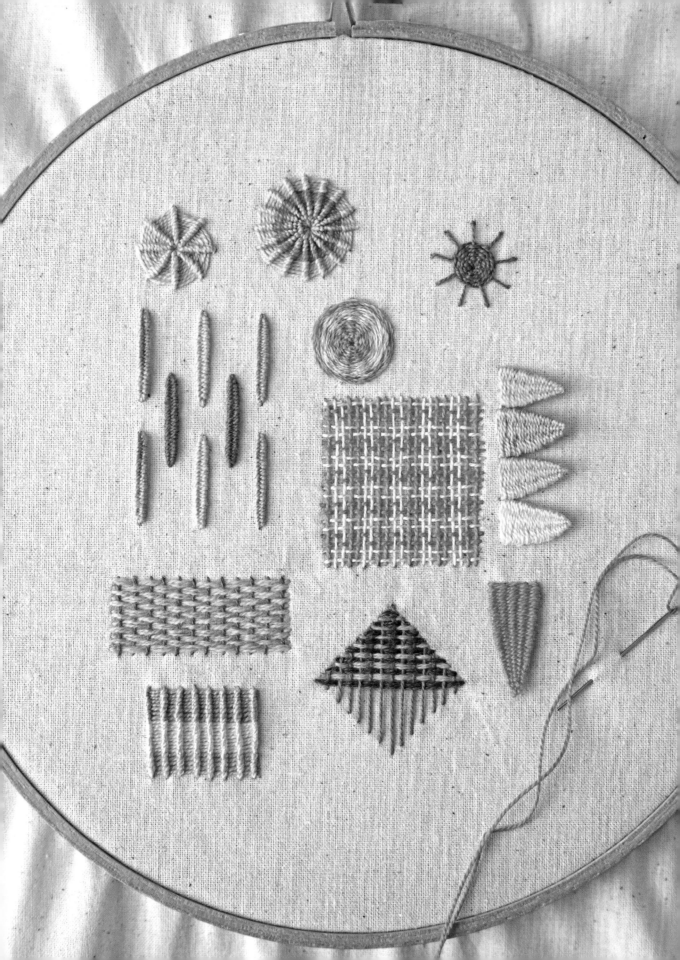

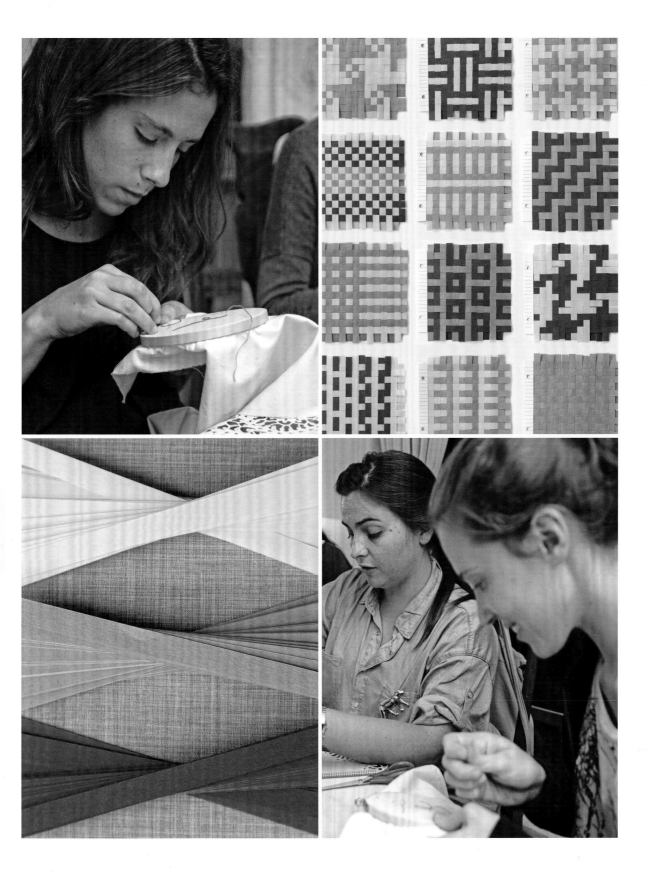

Template: **Sleeping mask**

COLOUR CHART

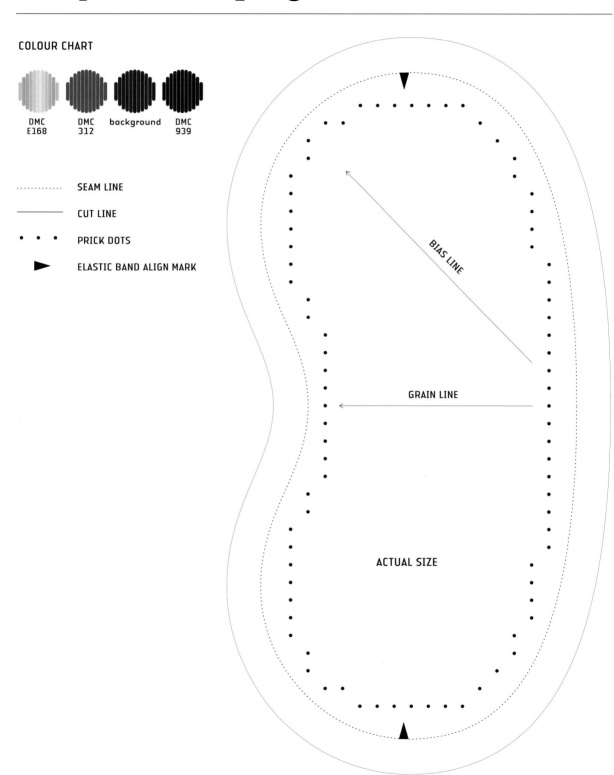

DMC E168	DMC 312	background	DMC 939

·········· SEAM LINE

────── CUT LINE

• • • PRICK DOTS

► ELASTIC BAND ALIGN MARK

BIAS LINE

GRAIN LINE

ACTUAL SIZE

Pattern: **Embellished knitted sleeves**

COLOUR CHART

| Appleton 564 | Appleton 565 | Appleton 562 | Appleton 561 | Appleton 743 | Appleton 746 | Appleton 105 | Appleton 104 | Appleton 103 | Appleton 101 | Appleton 885 |

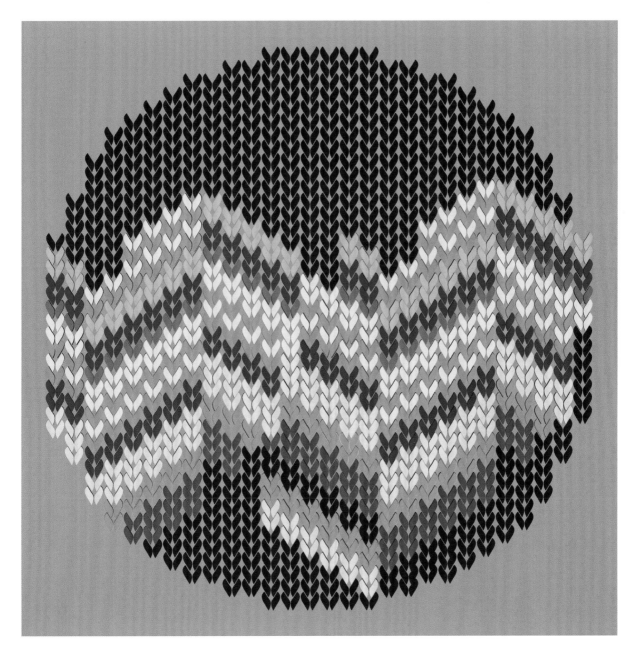

Pattern: **Tea towel with woven patches**

DMC
822

DMC
309

DMC
503

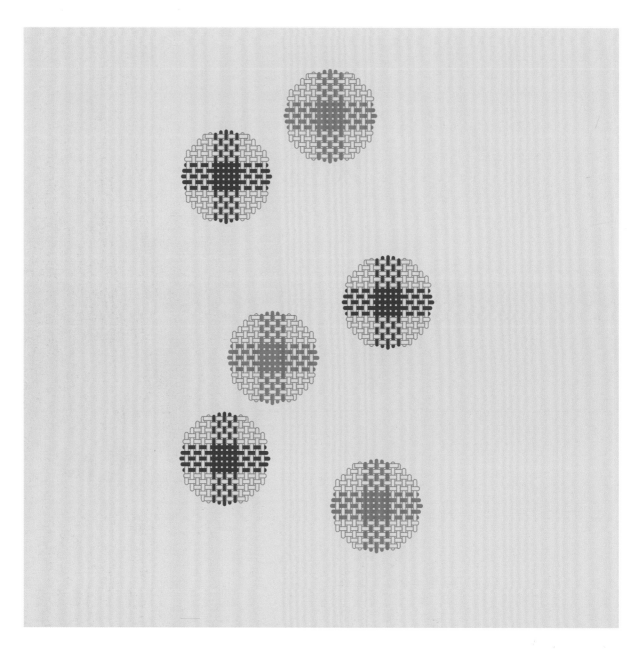

Template: **Framed embroidery**

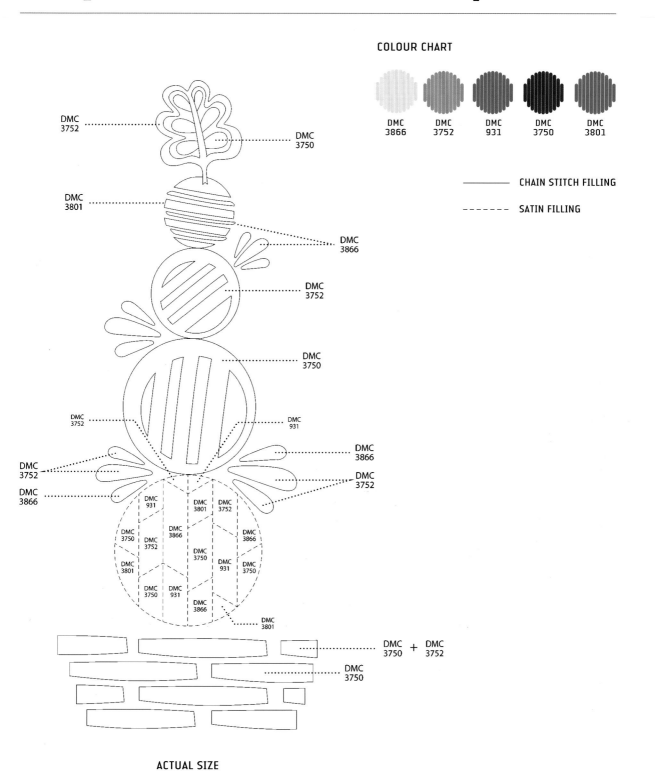

COLOUR CHART

| DMC 3866 | DMC 3752 | DMC 931 | DMC 3750 | DMC 3801 |

—————— CHAIN STITCH FILLING

- - - - - - SATIN FILLING

DMC 3752
DMC 3750
DMC 3801
DMC 3866
DMC 3752
DMC 3750
DMC 3752
DMC 931
DMC 3866
DMC 3752
DMC 3752
DMC 3866

DMC 931
DMC 3801
DMC 3752
DMC 3750
DMC 3752
DMC 3866
DMC 3866
DMC 3750
DMC 3752
DMC 3750
DMC 931
DMC 3750
DMC 3801
DMC 3750
DMC 931
DMC 3866
DMC 3801

DMC 3750 + DMC 3752
DMC 3750

ACTUAL SIZE

Templates:
Cross-stitch
tea party

COLOUR CHART FOR CHERRY TEABAG

| DMC 3862 Tea leaves | DMC 938 Outline and string | DMC 3371 Cherry darker area | DMC 3328 Cherry lighter area | DMC 712 Cherry highlight |

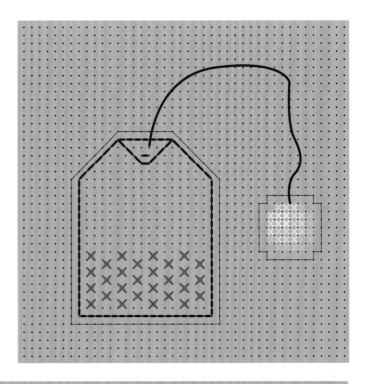

COLOUR CHART FOR FACE

| DMC 3862 Hair and nose | DMC 938 Eyes and mouth | DMC 3371 Cheeks |

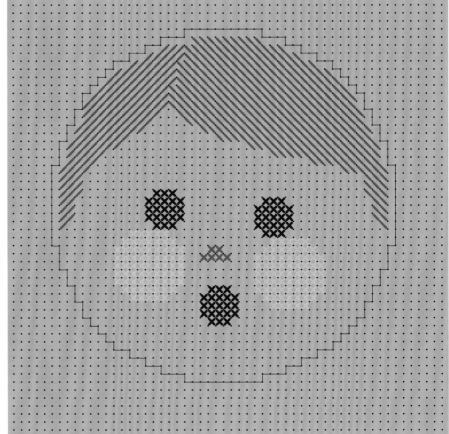

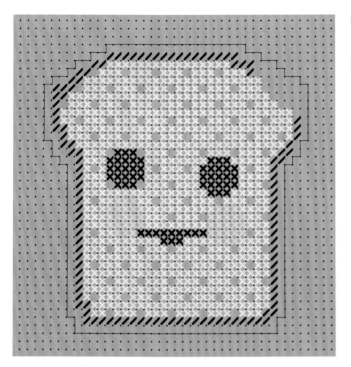

COLOUR CHART FOR TOAST

DMC 938	DMC 3328	DMC 712
Crust, eyes and mouth	Cheeks	Toast

COLOUR CHART FOR CUP

DMC 938	DMC 3371	DMC 3328	DMC 712
Top scallops	Middle scallops	Bottom scallops	Cup base and handle

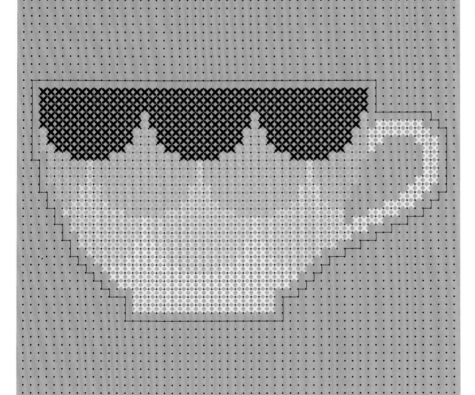

 FULL CROSS-STITCH

 HALF CROSS-STITCH

 BACKSTITCH

 PERFORATIONS

 CUT LINE

Index